Sketching

with

JAMES HORTON

First published in 1988
by William Collins Sons & Co., Ltd
London · Glasgow · Sydney
Auckland · Toronto · Johannesburg

Reprinted 1989

British Library Cataloguing in Publication Data
Horton, James
 James Horton – Artist's Sketchbook
 1. Drawing
 I. Title
 741.2 NC710

ISBN 0 00 412257 7

Designed by Caroline Hill
Filmset by J&L Composition Ltd
Originated, printed and bound in
Hong Kong by Wing King Tong Co. Ltd

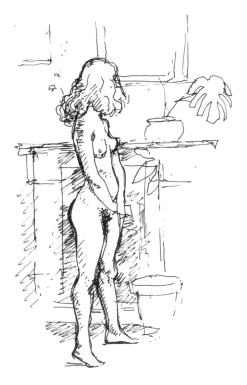

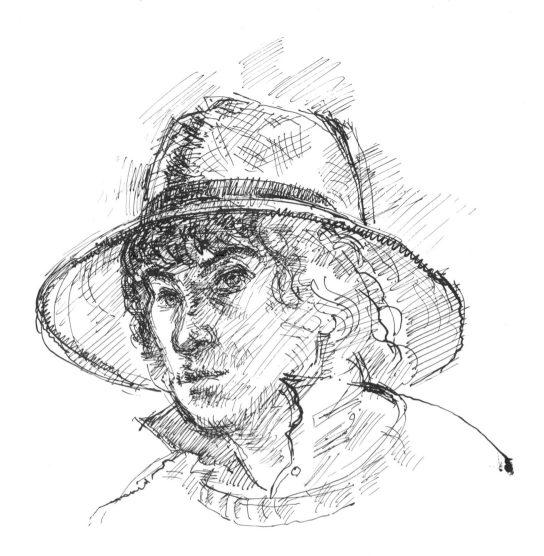

PORTRAIT OF THE ARTIST

James Horton was born in London and now lives and works in Cambridge. For two years he studied drawing and painting at the Sir John Cass School of Art and then continued his studies for a further four years at City & Guilds School of Art, a small art school which favoured working from life and figurative art in general. During this period he also spent a good deal of time working upon figurative sculpture, and before going on to the Royal College of Art for three years he was awarded a scholarship to Florence to study the Renaissance painters and sculptors.

James Horton's work has been exhibited widely in Britain and abroad, including at the Royal Academy summer shows and the Royal Portrait Society, and he has staged six one-man shows. In 1980 he was elected to the Royal Society of British Artists.

His work varies in size enormously from the small, freshly painted landscapes or figure studies always made from life, to the large figurative subjects which take many months to plan and execute. When he is not devoting time to his own work, James Horton is a known and respected teacher of art, finding inspiration for his work from his students. As a writer he has published articles regularly since 1978 for *The Artist* magazine and he is also the author of *Learn to Draw the Figure*, published by Collins.

One of the most delightful aspects of an artist's sketchbook is that if we are given the chance to look through its pages it can offer an enlightening glimpse of the way that artist works. This is something which fascinates and appeals to many people, whether they are artists themselves or not, perhaps because it is very satisfying to have a greater understanding of the methods and techniques behind a finished painting or drawing. Often a sketchbook becomes almost an integral, indispensable part of an artist so that it begins to reflect his character through the way in which sketches, drawings and notes are compiled. In fact, there are some artists whose main work is to be found in their sketchbooks.

Changing attitudes towards sketchbooks

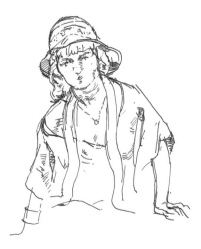

Nowadays we regard the sketchbook as an accepted part of an artist's equipment and an important contribution to his work as a whole, but this of course has not always been the case. During the Renaissance the sketchbook did not have the same status as it does today, and the further back one goes into history the less evidence of sketchbooks there seems to be. One of the reasons for this is that paper was not so easily come by in those days and paper bound into a book form just for drawing was probably fairly unusual. Paper-making, before and during the Renaissance, was of an excellent standard, the paper being made solely by hand from very good-quality materials. However, this tended to produce a paper that was quite heavy in weight and therefore not particularly suited to folding and binding, at least on a small scale.

There was another and more likely reason why sketchbooks were not used as much then as now and this was because the aesthetic

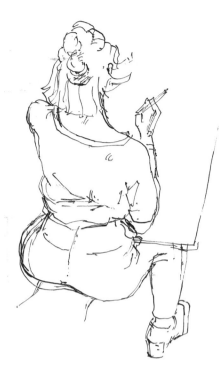

status of drawing was entirely different. There were basically two types of drawing that the early artists were likely to make. The first was a working drawing, which would be a thoroughly exploratory work usually in the form of a composition sketch for a painting or studies relating to parts of a finished piece of work. These working drawings by the master were intended for the workshop and were generally thought not to be fit for viewing except by those who had specific reasons to do so, such as the client for approval and the apprentices for working from. Often, once the final work was complete, these drawings, their usefulness over, would be destroyed. Michelangelo is known to have destroyed a number of studies for the Sistine Chapel for this reason.

The other type of drawing made by early artists was a highly finished work, in the nature of a portrait or religious scene, but with the emphasis on facility, polish and presentation, produced especially for a client. For both types of drawing individual sheets of paper would be used: working drawings, which were to be painted from, required several sheets to be visible at once; and presentation drawings would be mounted and framed upon completion. As a result, neither procedure was particularly suited to sketchbook work.

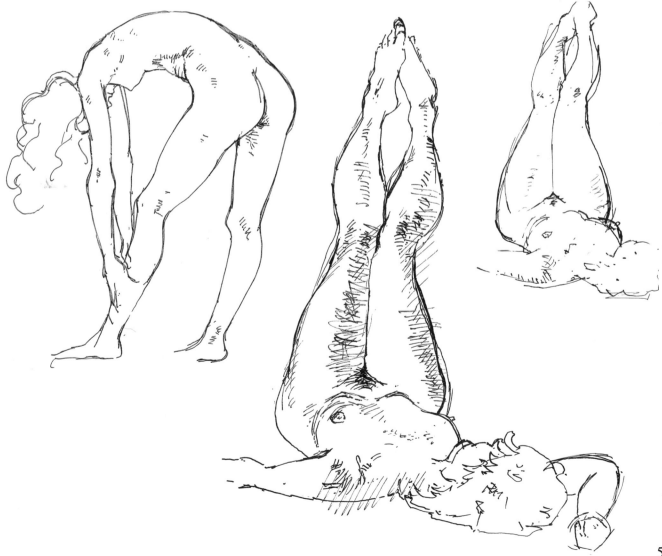

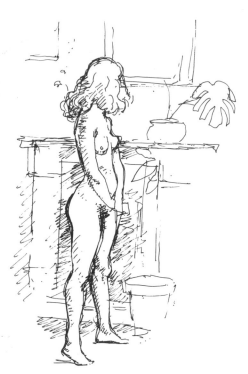

One exception to this practice that immediately comes to mind are Leonardo's notebooks, but here the emphasis was as much scientific as artistic, if not more so, as many of his drawings were of a technical nature, concerned with anatomy, aeronautics and other similar subjects. It was not until paintings and sculpture became free of the excessive grandeur and formality of those early times that artists began to keep sketchbooks as a way of recording a more personal approach to their art. In this way the sketchbook became an important medium in its own right as a vehicle for ideas and for making statements that could be kept and assessed at a later stage.

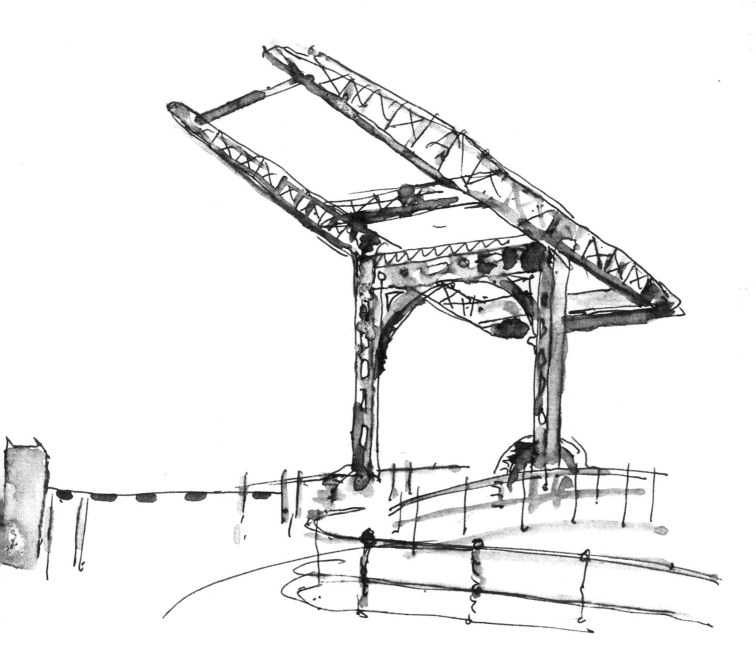

Looking at other artists' sketchbooks

During the nineteenth century sketchbooks were invariably used as a topographical record of a tour, the sketches in them being made into finished paintings upon return to the studio. However, at this time a sketchbook was still a rather private document and, for the most part, not intended for public viewing. The most notable collection of sketchbooks of this type are of course those by J.M.W. Turner; but even this great artist, as innovative as he was, still pursued the traditional line of presenting considered, studied and, on the whole, finished pictures for exhibition, using his sketchbooks simply as the source for these. That is not to say that Turner himself

did not regard his sketchbook work as 'valid' art; I am sure that he did, particularly when one considers that a major part of his life's work was executed in sketchbooks.

Today we are quite used to seeing sketchbooks by well-known artists like Turner or Constable on display for both historical and artistic reasons. Sketchbooks by contemporary artists, too, are often on show at exhibitions, perhaps just for their own sake but also because they can indeed enhance the appreciation of certain works to which they may relate. Obviously different artists use their sketchbooks in different ways, some being more private than others, maybe containing poems or personal writings as well as sketches, but whatever the content of a sketchbook there is no doubt that to be able to study one gives a tremendous insight into that artist's work. It is this shift in importance of the 'finished' as opposed to the 'working' methods that has become so apparent in more recent times. Whereas once sketches and working drawings were considered to be tantamount to 'dirty washing', never to be hung out on the line, we now value all the preparatory work put into a painting and any sketches or drawings which exist either in sketchbooks or on loose scraps of paper. In fact, in many ways the change in conception of great art, in this matter, has almost gone to the other extreme and some people now have an aversion to anything that is too finished. John Constable, for example, has suffered more than most in this respect as many historians value his large sketches more than the final works.

The value of an artist's sketchbook

What is not in question, however, is the inspiration that can be gained by looking at sketches and how they have been put together: to see exactly how a wash was applied and perhaps overdrawn with pen or pencil drawings, which probe deeply into a subject, maybe with multiple images, is the stuff of sketchbooks. Even the initial selection of subject matter and its subsequent development is of great interest to others. To a practising artist all of these elements are instructive and inspirational and to an interested observer they offer a chance to understand a little more of the processes involved in drawing.

Sketchbooks are often used for a particular purpose – for example, those kept in the form of a travel diary. The great period of travel diaries was Victorian England, the heyday of the Grand Tour, when just about everybody kept a journal such as this. It did not end with diaries either – many artists illustrated their letters to friends and family as well. I know of many artists today who use a sketchbook as a record in words and pictures of a holiday or painting trip. I always keep a book like this when travelling, to jot down notes and sketches of incidents and places; the result is somewhat anecdotal.

Very often these travel diaries are the most entertaining sketchbooks of all. I say 'entertaining' because that is indeed what they do – entertain. To the artist they provide an unselfconscious way of recording a trip and the events which were outstanding for whatever reason. The drawings are usually not done with great academic

accuracy but are more like gestures which capture the essence of each subject and above all are keen reminders of specific occasions. This also means, incidentally, that a travel sketchbook makes a wonderfully interesting document to anyone else reading it. Of course, to simplify and capture fleeting moments successfully in this way demands good draughtsmanship – but this is the very thing that sketchbooks are good for: practising drawing. This is one reason why most artists always carry a sketchbook around with them so that they never miss an opportunity to practise – and thereby improve – their drawing.

Sketchbooks and other work

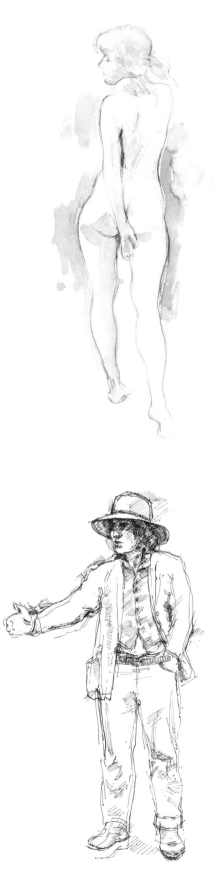

Strangely enough, I never used to regard myself particularly as a sketchbook artist, but my use of sketchbooks has increased and widened a great deal over the years. As a student I was often in trouble for not keeping a 'proper sketchbook'. As a tutor myself now I find looking at students' sketchbooks an invaluable way of getting to know them and assessing their work, so I can sympathize with my own tutors at my reluctance to use one. This was not because I was lazy or indifferent, but my inclination in those days was to draw on separate sheets of paper, rather like the Renaissance artists. There was also the fact that I did not really understand how I should use a sketchbook, at least in relation to my own work. That might seem unlikely, but I was certainly not alone in this. To use a sketchbook so that it assists your work is not as easy as it sounds. For a start, you need to know what your work is all about, to have a clear idea about the direction in which you see your work developing, which as a student has often not been established. Many amateurs also have problems with sketchbooks because they are not quite sure what to put in them! Clearly a sketchbook, as opposed to a notebook, is a vehicle for someone whose work is based largely upon observation of life, or nature as it is known in art. If you are an artist who enjoys composing pictures then a sketchbook is the obvious place to assemble all your ideas. If, on the other hand, you enjoy working from life without any thoughts of developing the picture further, the sketchbook still suffices as a place to try out ideas with different media. Your sketchbook should be a place where you can be totally private and honest, without worrying about the excellence of the results, only the value of constructing them. In this way everyone should develop their own attitude towards their sketchbooks. As this happens, so should the relationship between finished paintings or presentation pictures and sketchbook work develop.

For me a sketchbook has never been a medium for writing and making notes but a purely visual extension of my everyday work. As a figurative and objective painter the sketches in my sketchbooks centre almost exclusively around my drawing from life wherever I happen to be, and as I spend a good deal of my time working from models, the nude features a great deal. In fact, I have a vast number of sketchbooks which have been compiled in the life room, as an extension to my teaching, which contain only nudes.

Many of the sketches in my sketchbook are made as studies and preparations for particular paintings. The figure here, for example, was drawn as a first idea for a character which will eventually be used in a large painting. In many ways it is tempting to make studies like this on separate sheets of paper because when the painting is in progress it can be irritating to be constantly flicking through a sketchbook looking for the relevant information. In this way, I suppose, I use a sketchbook more in the traditional way, sketching a specific subject rather than anything that happens to be on hand.

This is not to say, of course, that I never use my sketchbook for work other than specific studies. The watercolour on page 36 was

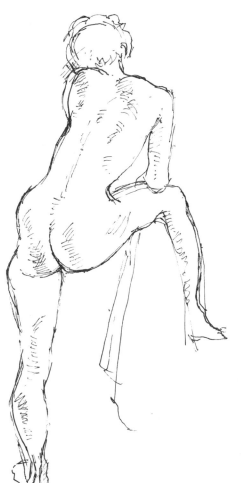

made when staying at a friend's house in Suffolk and as an idea was never developed into anything else. It is a piece of work that exists solely in sketchbook form and was done purely for the joy of doing it. This is also true of the watercolour of Amsterdam on pages 34–5 which I made on a recent trip there. Spontaneous drawings of this kind, which are done simply because I happen to have my sketchbook with me, are rarely taken into another stage. They are sketches for their own sake and in a way can be seen as more elaborate versions of the kind of drawings made in a travel diary.

On the other hand, the nudes in interiors on pages 42 and 43 were existing sketches taken from old sketchbooks; taking great care to keep the lighting consistent, I put them into various different environments based on rooms in my house. The models in question for these composition sketches often did not actually pose in the areas shown; these were amalgamated from different sources. In the same way I often go through my old sketchbooks of nudes and single out random poses done some time before that I feel have potential for being developed into paintings.

This is a very valuable part of the sketchbook process and an aspect I would suggest all readers consider. Although very often when drawings are made initially in a sketchbook it is without a precise idea about how they will be used, they may with later consideration be able to form the basis of a painting, providing useful reference to the original subjects.

Many artists use a sketchbook in this way to record the everyday objects and people that are present at a particular moment in time,

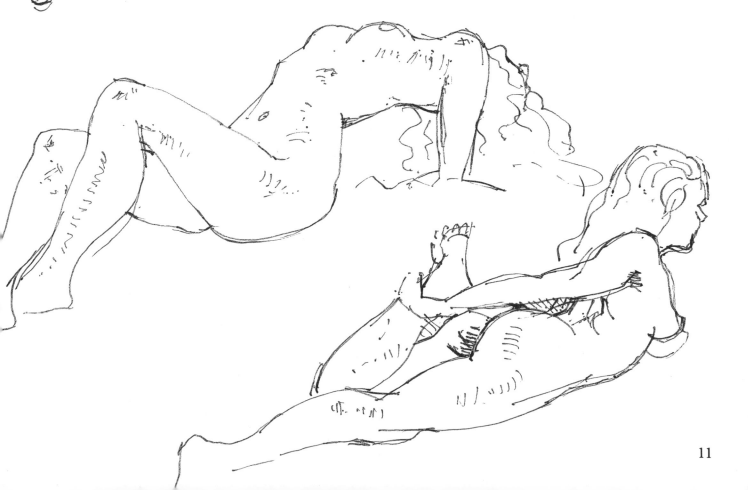

11

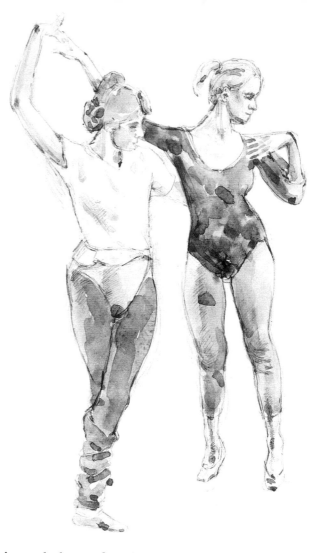

having no intended use for the sketches immediately but keeping them as a visual reference library. These drawings can then be referred to at a later stage, when a particular figure or object is needed for part of a painting. In such cases, whatever the method used for transferring these sketches into paintings, the advantage of having them all bound together in a single volume, readily accessible, becomes increasingly obvious.

Good subjects for sketching

Closely related to drawing the nude but with an added dimension of movement is drawing dancers at work. For some time now I have been interested in the sketching opportunities offered by dancers and I have spent many hours in dance studios drawing dancers working their way through routines or exercising. I usually make a number of varied sketches and later assemble the information gained from them in a larger and more considered work. On other occasions I have sketched a dancer posing for short periods; this might be for five minutes, perhaps, but generally not much longer than that or the spontaneity and character of movement can be lost. Some sketches of dancers in five-minute poses done with a black wash and white gouache on toned paper are shown on pages 18 and 19. I also used a pen to strengthen parts of the drawings. I find this combination of media extremely versatile and capable of making rapid statements convincingly.

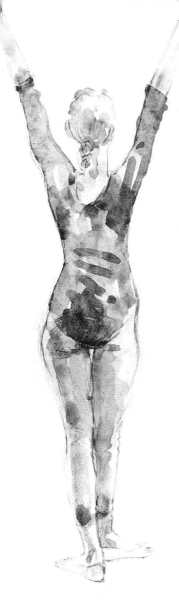

Such five-minute poses can be very helpful to an artist by encouraging him to work boldly and decisively. Once into the swing of things one becomes increasingly confident and takes more chances; as a result, it is more likely that a genuinely spontaneous effect will be achieved. It is important to commit yourself very positively in your drawing even if, by taking chances, you risk spoiling the sketch; ultimately you will learn far more this way. This is another valuable aspect of using a sketchbook: because the drawings in it tend to be regarded as 'working' sketches it does not matter if some of them are 'failures'. In fact, a sketch should never be regarded as a failure in the ordinary sense of the word because such a lot can subsequently be learnt from it. Every mark that an artist makes is in reality a valid statement about the way he feels at any given time. If that mark does not accurately convey what the artist has seen or felt, by studying its shortcomings he will be able to improve on it in the future. If a sketchbook is treated entirely honestly, therefore, all the mistakes and failures will appear alongside the really inspired pieces of work, which, as far as I am concerned, is of great value when trying to assess progress.

Speed for its own sake is never a worthwhile attribute, but to work swiftly with strength and accuracy to record a fleeting or very temporary image certainly is. However, although short poses encourage spontaneity, there are also occasions when it is interesting to spend a little longer on a study. The drawings illustrated here are examples of this. These poses were held for longer because this enabled me to explore in depth some of the other aspects of dancers. Instead of a pen I used a pencil to help give the drawings a slightly softer effect; used while the wash is still wet, it results in a wonderful, increased sensitivity. The watercolour which is reproduced in colour on page 37 is perhaps the most involved of all of these studies of dancers and goes the furthest towards laying the foundation for a painting, or even a large pastel.

Sketching musicians at work

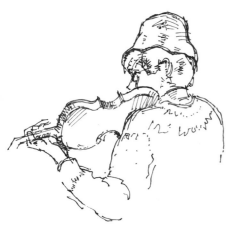

Another of the subjects I find myself drawn to is musicians. Whether or not it is a group of well-known musicians or just friends making music at home makes little difference; I always find that musicians rehearsing produce an atmosphere which is very conducive to drawing and painting. A group of musicians, in particular, offers great possibilities in compositional ideas, especially if the players are squashed together in a smallish area.

One of the watercolours shown on page 48 was done during a regular practice session of a recorder ensemble. None of the players actually posed; I just sat quietly whilst they rehearsed and sketched what I could. I was aware as I made this sketch that this was potential material for developing into a larger painting later on, so in order to get a better idea of composition I enclosed the scene in a frame, in something like the proportion I would eventually use. The lighting on this occasion was rather dramatic due to spotlights and this produced some very interesting effects across the tightly packed

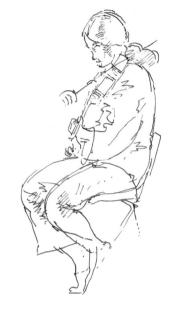

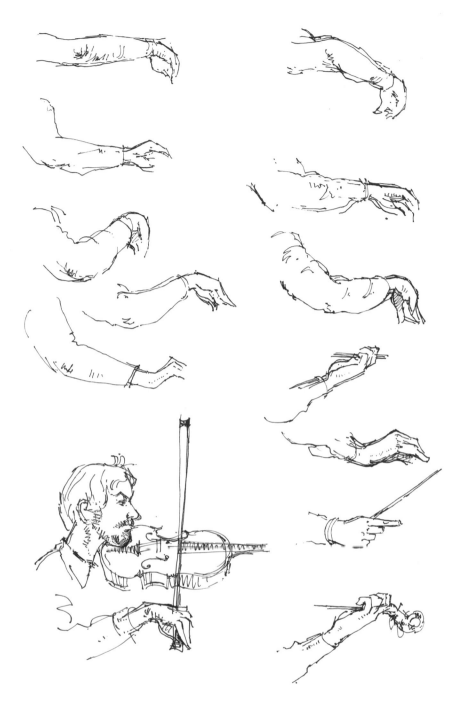

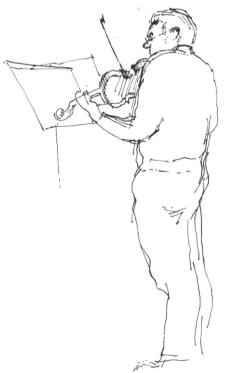

group. It was for this reason that I used colour for the sketches to try to re-create the atmosphere of an interior with artificial lighting and figures coming in and out of the shadows.

In the same way that dancers repeat movements, so musicians also repeat their movements to a larger degree. This obviously helps a great deal when drawing, for it enables you to study the effect of movement within certain activities. Illustrated here, for instance, are several studies of the bowing arm of a violinist. In these, not only was I trying to achieve a high degree of authenticity, but I was also aiming to record the variations in the whole movement. These studies, along with other similar ones, were later used in a large composition of a string quartet. All of these sketches were executed with pen and ink, a medium I find suited to sketchbook work in general because of the

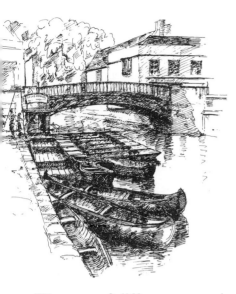

finality of the statements. The fact that an ink line cannot be erased means that mistakes can only be corrected by redrawing, which encourages strength and confidence in contour value when making these sorts of studies.

Although the majority of work in my sketchbooks tends to be figurative – and by that I mean containing figures – I also often sketch landscapes. These tend to range from fields, meadows or coastal scenes to architectural subjects or townscapes – it obviously depends upon where I am and how much time I have to spare. Sometimes, if I am out on a long painting session I might work on separate and probably pre-prepared sheets which can later be framed; but if time is short or the main picture is complete I find it is always a good idea to have my sketchbook handy so that I can use the time productively.

The use of different media

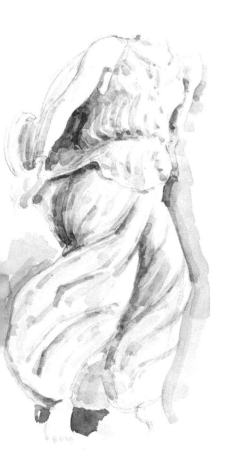

If there is one distinctive feature about my sketchbooks it is probably the variety of media that I use. I have always felt that it is essential to work in a good cross-section of media and the sketchbook should be no exception. Particularly in the case of studies or compositional ideas, I find it helpful to have plenty of colour to refer to. Although a drawing with written notes can be very useful, if colour is actually included in an idea which works out well in sketch form life is made a great deal easier when it comes to developing the sketch later in the studio.

Texture also plays an important part in the development of drawings and by mixing various media together a number of possibilities emerge. There is often a rather stubborn and unnatural adherence by some artists to the traditional wash-over-wash method of painting with watercolour. Certainly, pure wash drawings have great charm, but the addition of a little white gouache into a colour makes a great deal of difference to the amount of time it might take to make a drawing. This is not 'cheating', or debasing the art of watercolour; it simply gives you the chance to work opaquely in some areas and, of course, greatly increases the variety of toned paper that can be used. Very often when painting landscapes I use gouache, which is designed to be opaque and works in very different ways from watercolour. However, this usually entails carrying a palette and a selection of tubes, which all takes up valuable space and particularly time if it is at a premium. For working spontaneously in a sketchbook a small pocket-sized watercolour box with a dash of white gouache squeezed onto the lid provides much greater flexibility.

This was what I used for the beach scene on page 47, applying the paint with a medium-sized sable brush. This drawing was about an hour's work, as the looseness in the handling of the paint indicates. I was able to work on paper that I had toned myself with a wash, and apply opaque colours as opposed to the usual transparent colours that one would use on white paper. The advantage of this can be seen particularly in the clouds and the white areas on the boat. Very often, as already mentioned, I will use pen and ink as well to work over and strengthen a drawing.

Looking back, I am sure one of the reasons I found sketchbook work difficult as a student was because I did not like the paper contained in most commercially available sketchbooks. I was much happier using different papers of varying textures, weights and often tones. One glance at this sketchbook will reveal that I still do prefer a variety of paper. As a result, I have for many years made up my own sketchbooks with paper of my choice. The great advantage of this is that different coloured papers can be used in whatever order you wish. Toned paper can also have an effect upon the feeling of the sketch and in this way can be used to enhance the mood of the work. Making up a sketchbook with a rudimentary binding is really not that difficult, and even if it is too much of a problem I have found that having your own paper bound is not expensive – especially if the result is a beautiful surface to work upon. If this sounds a little on the elaborate side, consider the gain: you have a sketchbook that is a delight to work in instead of making do with something that you are not quite happy with.

**Feeling at ease
with a sketchbook**

A sketchbook needs to be a piece of your equipment that you are totally at one with, very much a part of you. It should be a joy to work in. For me, my sketchbooks are like an old, comfortable pair of trousers which I wear until they fall to pieces, without worrying about what people think in the meantime. Perhaps these analogies are a little exaggerated, but my point is that in many ways sketchbooks can form the foundation and even the character of an artist's work. To understand and, above all, to enjoy using one is therefore of paramount importance.

This particular sketchbook did present me, however, with challenges which I would not normally encounter. Because I knew that eventually it would be published, I was aware that this might have some effect upon the final product. I tried my hardest to work as I would do normally, though, and on the whole I think the nature and quality of the work here is just as I would produce in any of my sketchbooks, except, perhaps, in that it is a little neater than usual!

Having emphasized the essentially private nature of a sketchbook, I now have to qualify this by saying that this applies to the attitude relating to its compilation. In my case I am very used to people browsing through my sketchbooks – students, friends and colleagues alike. If a sketchbook is a piece of working equipment, as it is for me, then you should never mind anyone else looking through it. At the very least it should be entertaining and informative, and it may even inspire some people to go away and start sketching themselves – as I hope this one might do.

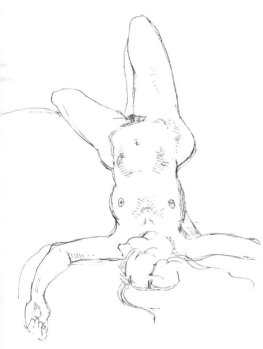

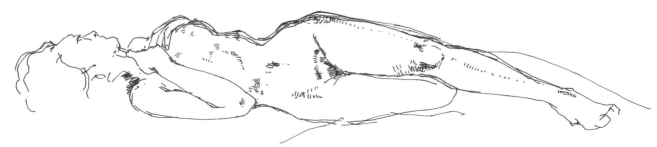

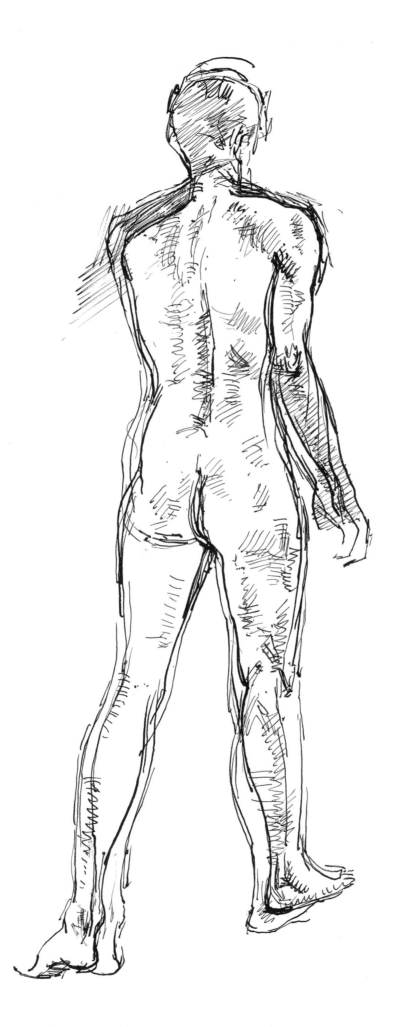

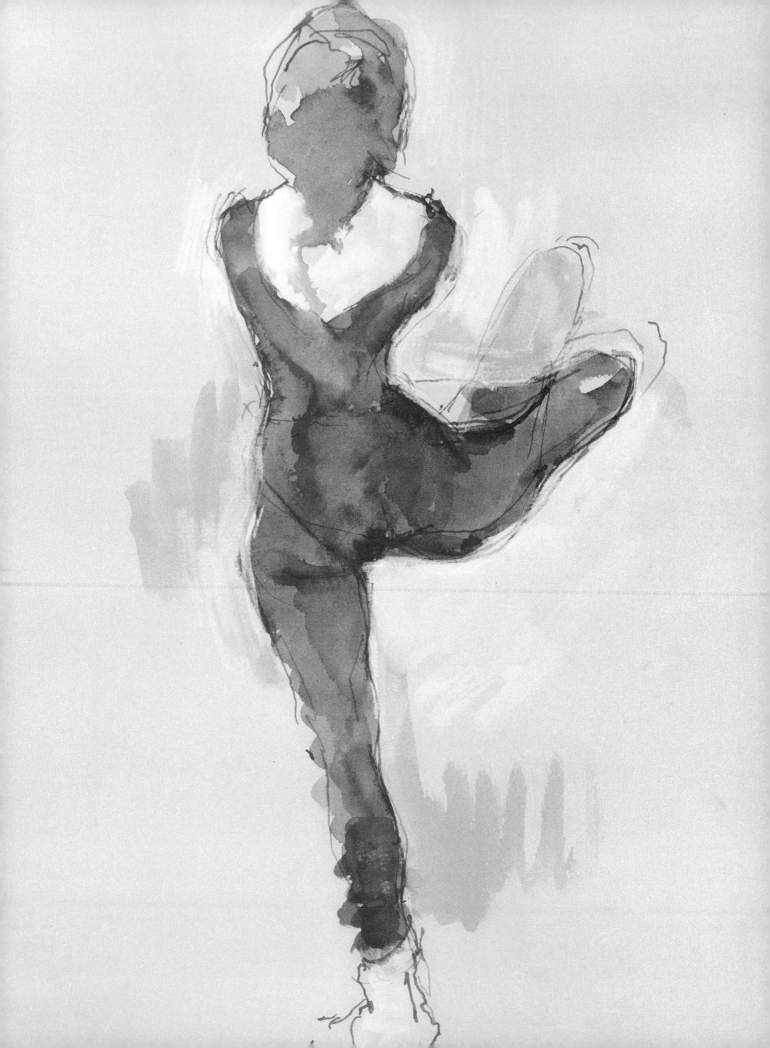

These studies were made from a dancer going through
warm-up routines. In order to capture the images swiftly
the materials were used without concern for neatness,
hence effects such as bleeding in the washes and strong
over-drawing on certain limbs.

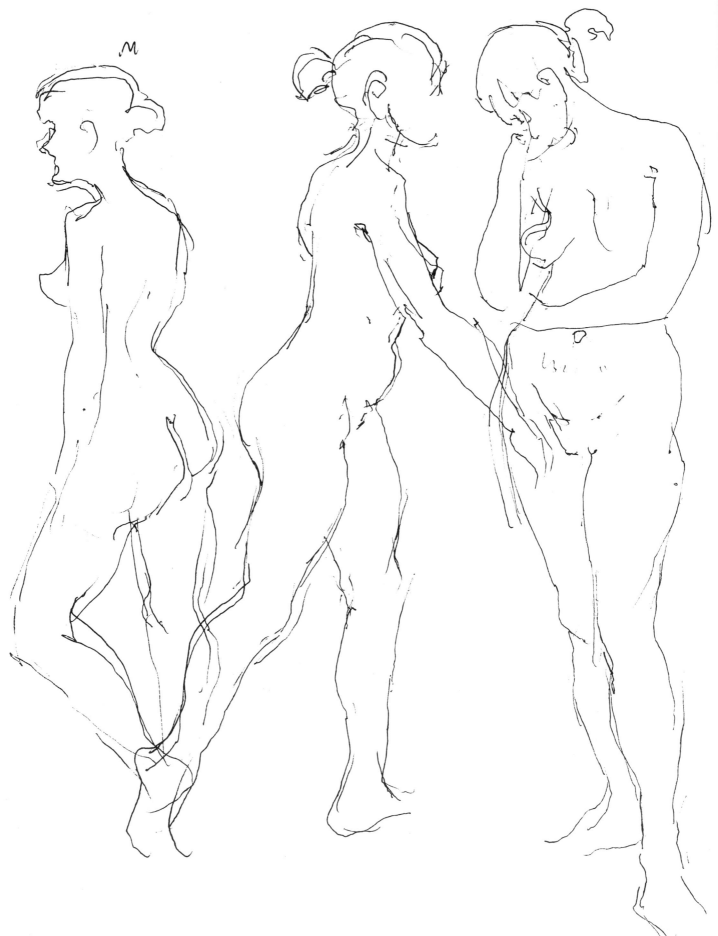

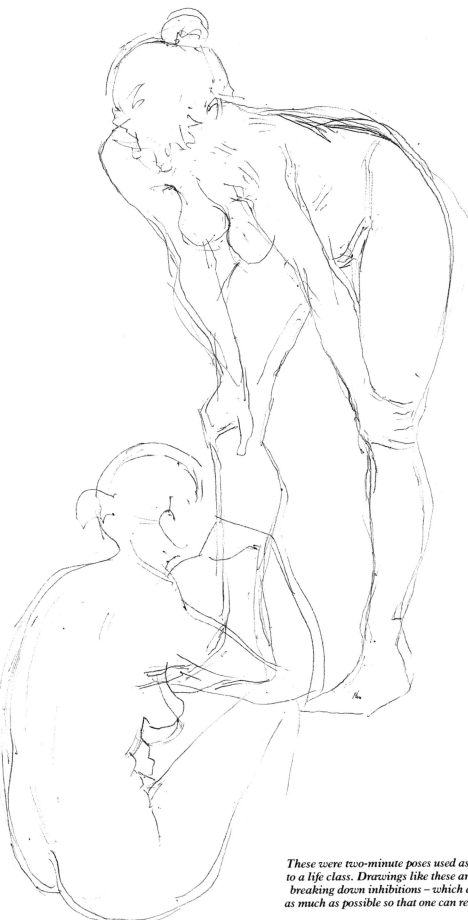

These were two-minute poses used as a warm-up session to a life class. Drawings like these are a valuable way of breaking down inhibitions – which are always present – as much as possible so that one can respond more fluently to a model.

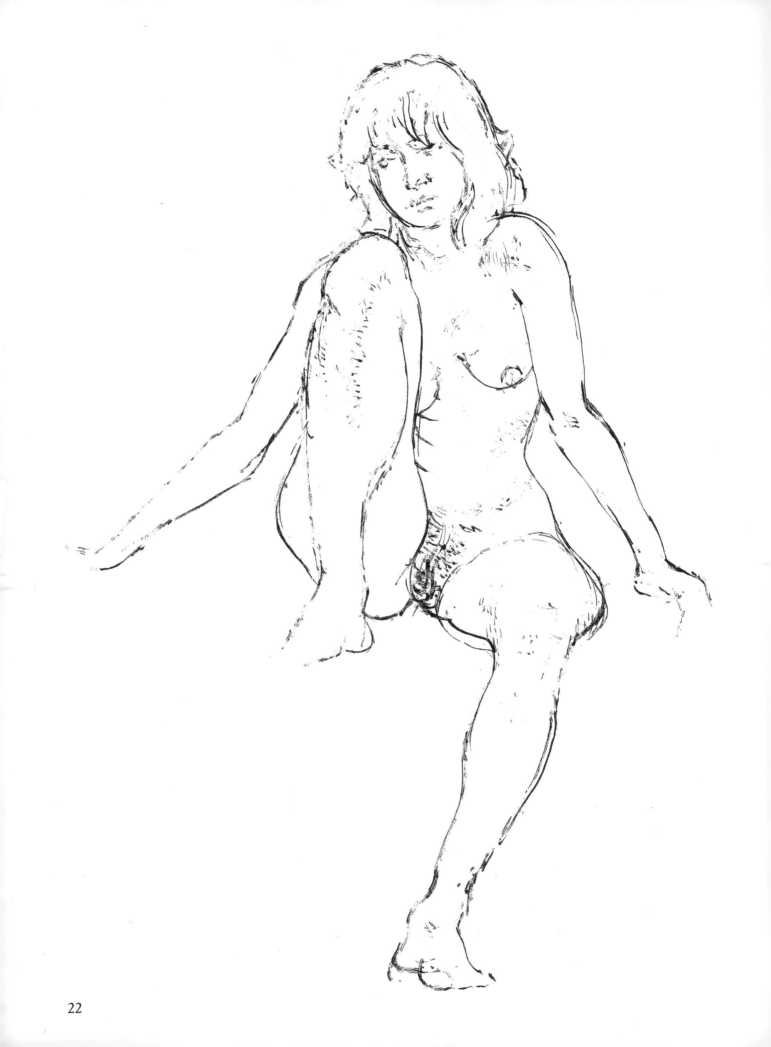

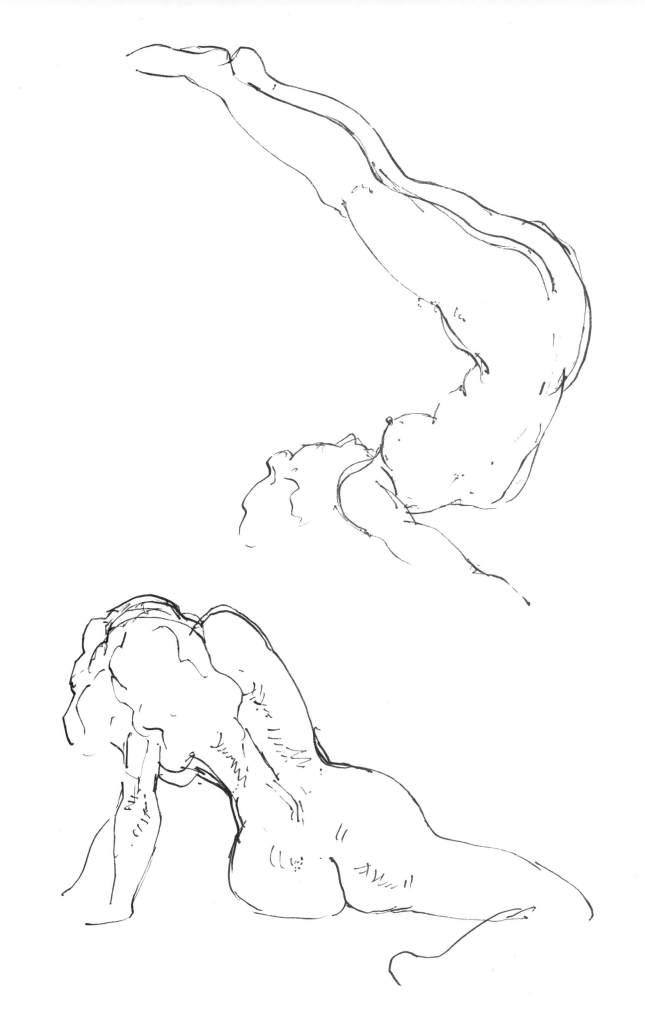

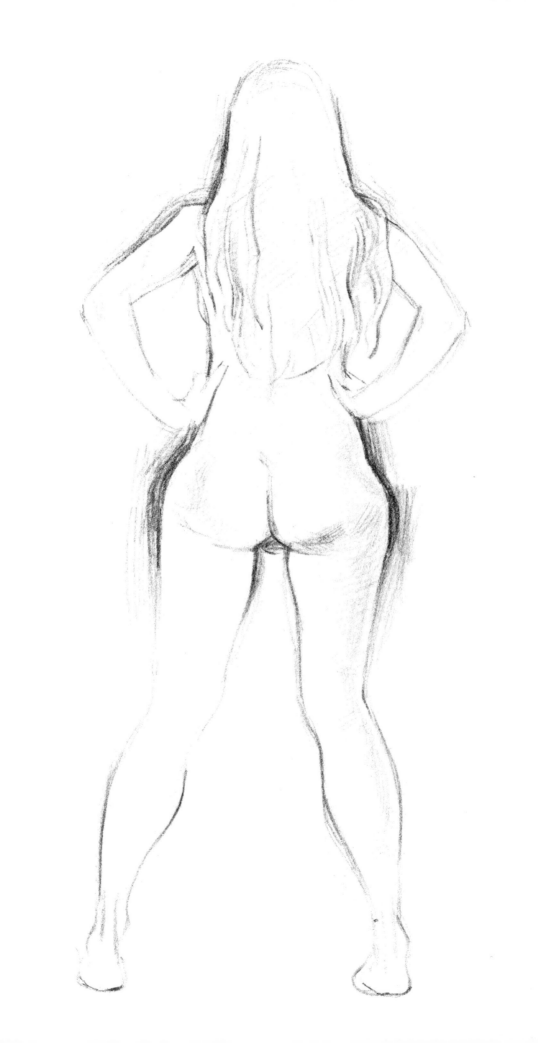

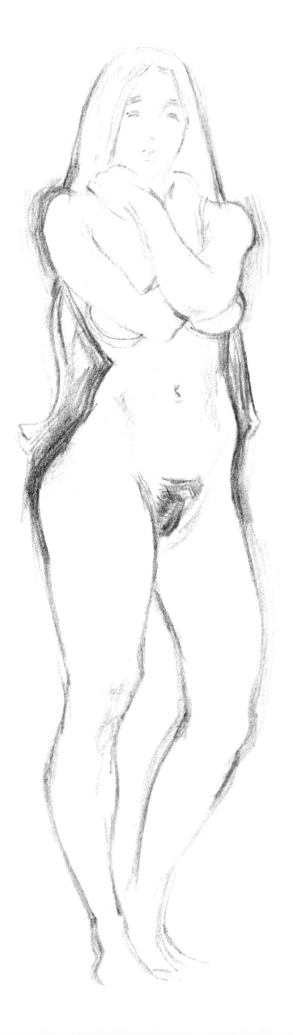

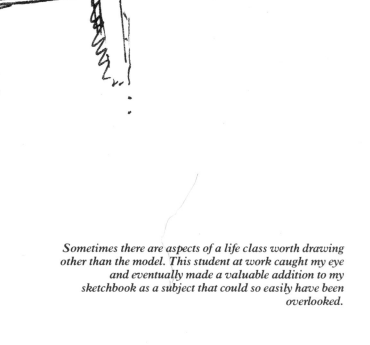

Sometimes there are aspects of a life class worth drawing other than the model. This student at work caught my eye and eventually made a valuable addition to my sketchbook as a subject that could so easily have been overlooked.

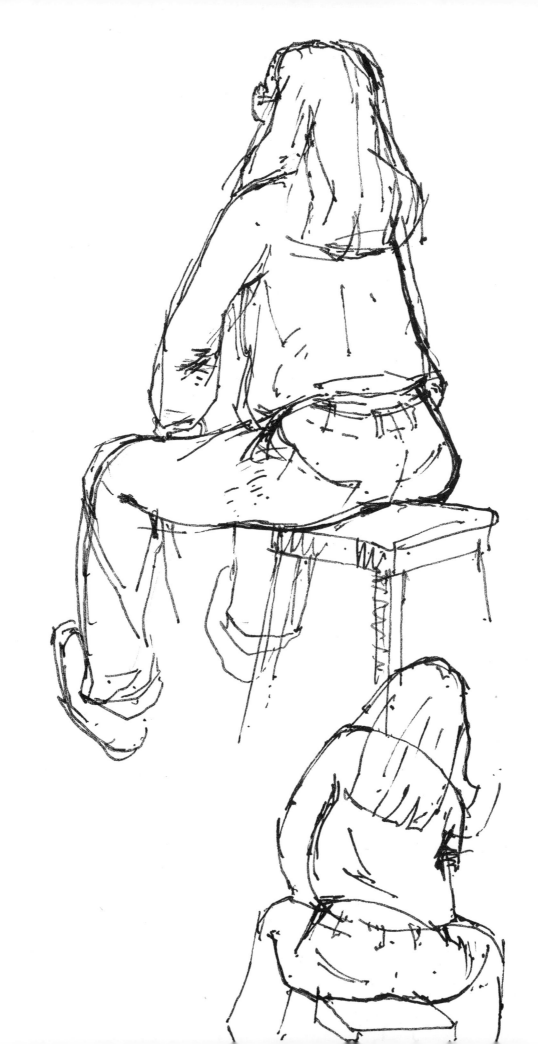

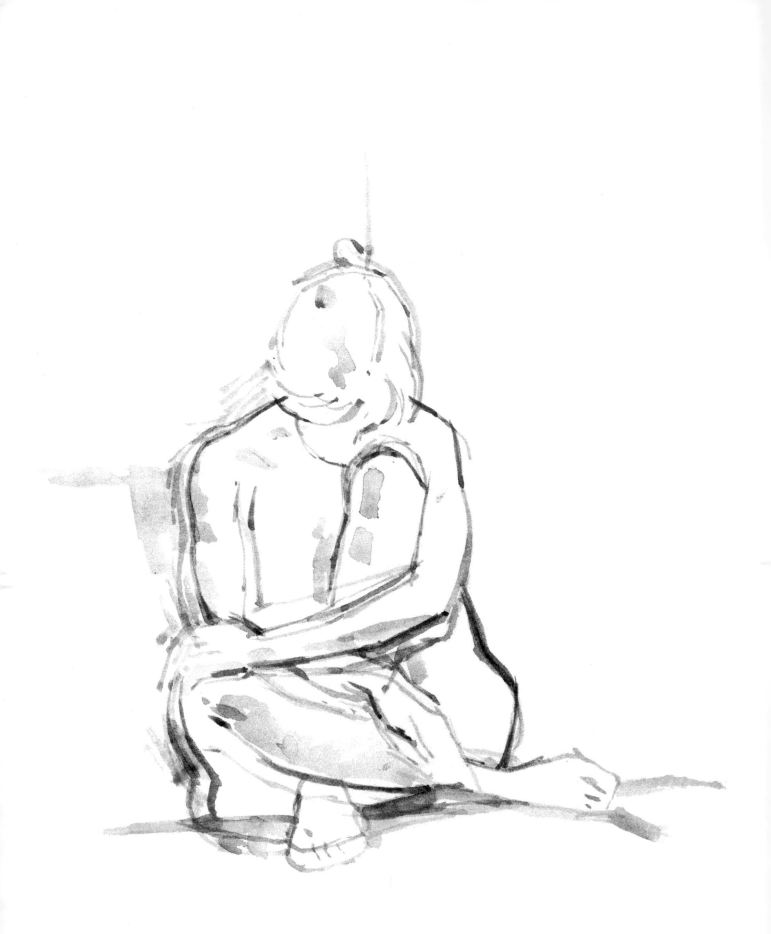

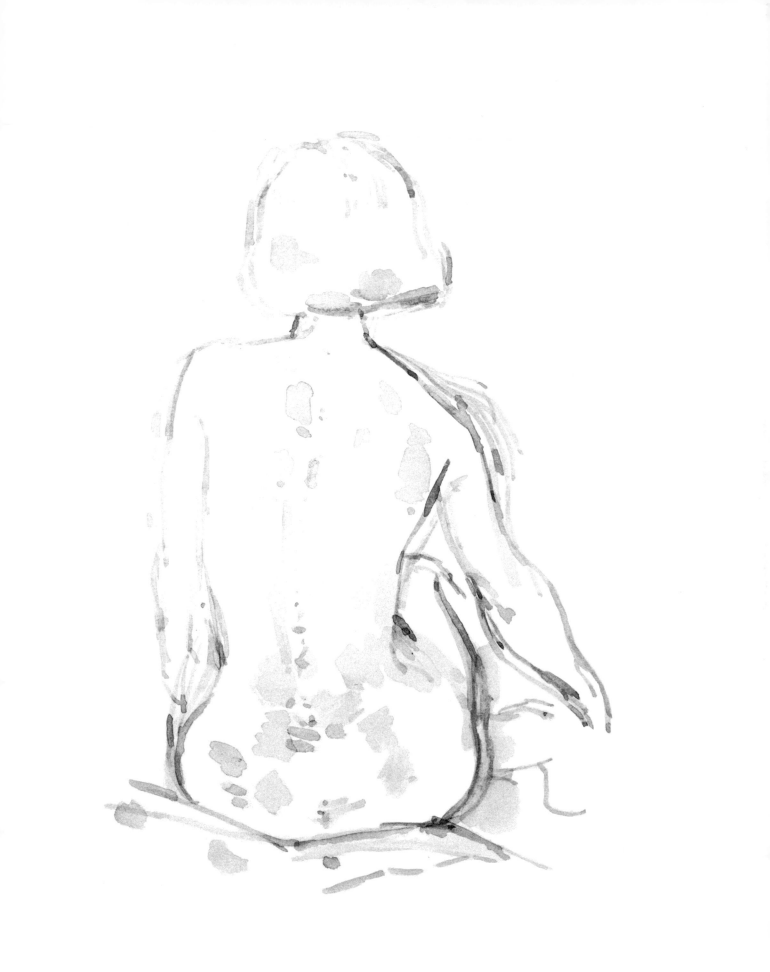

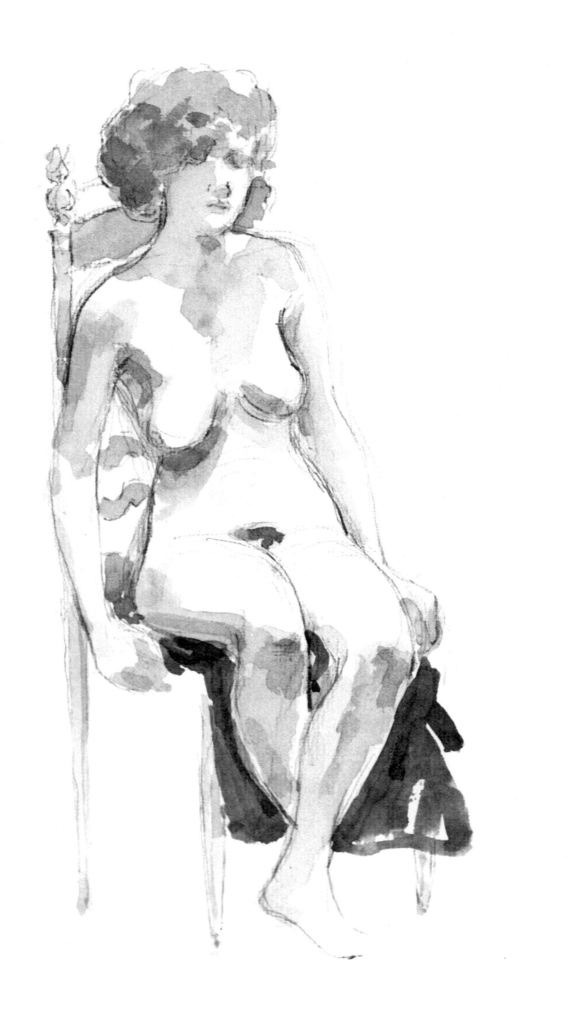

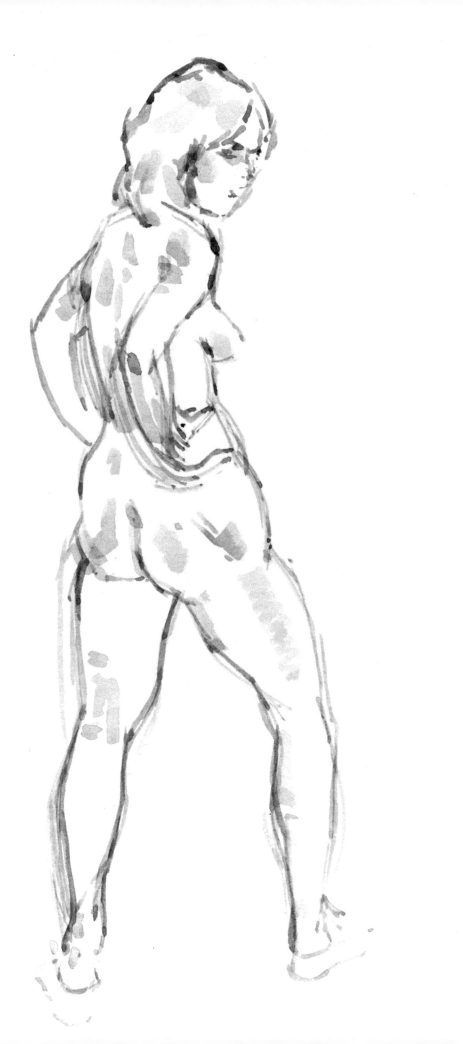

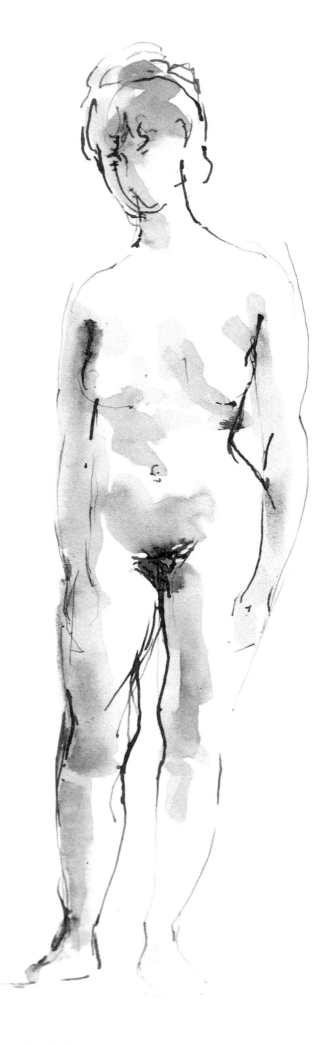

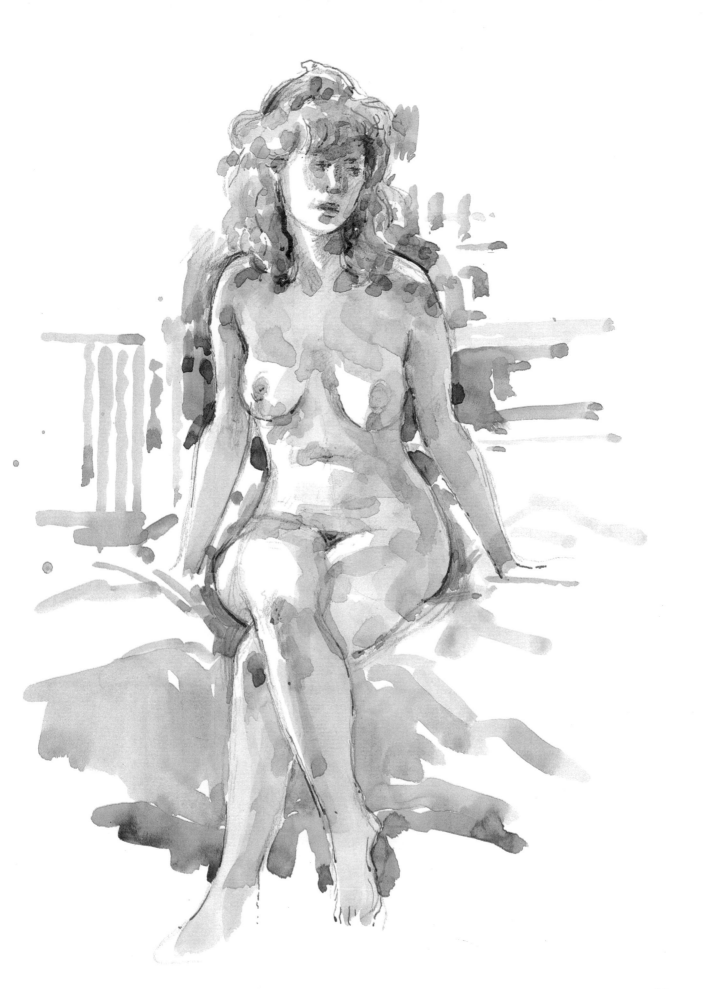

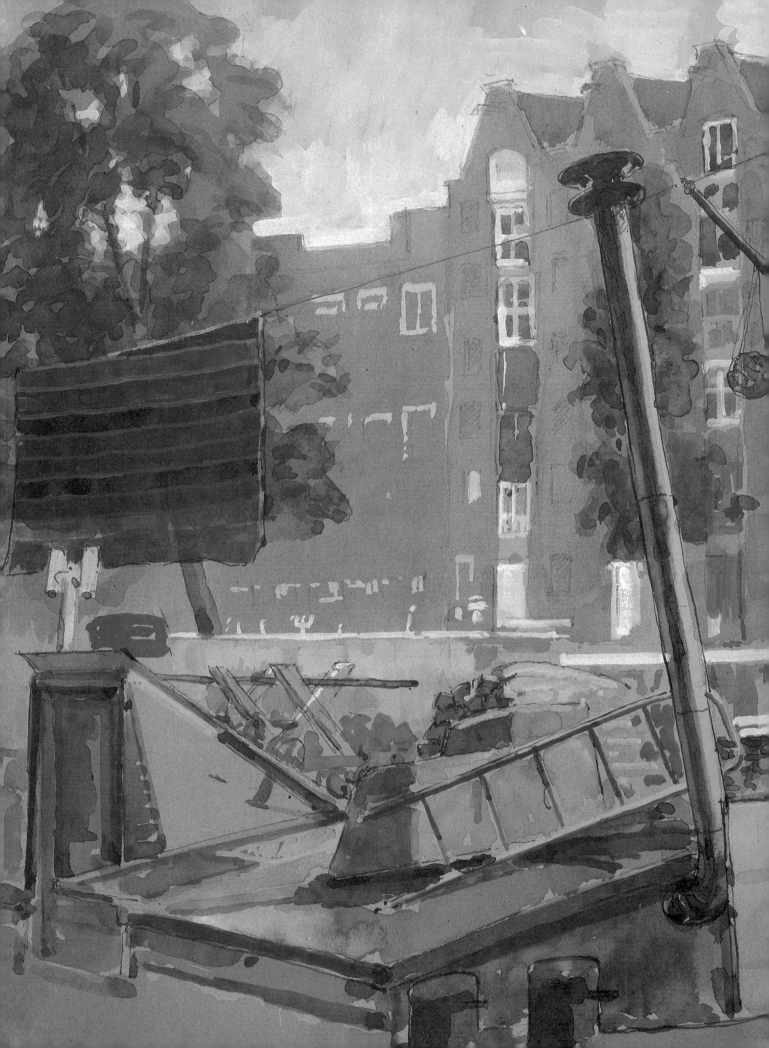

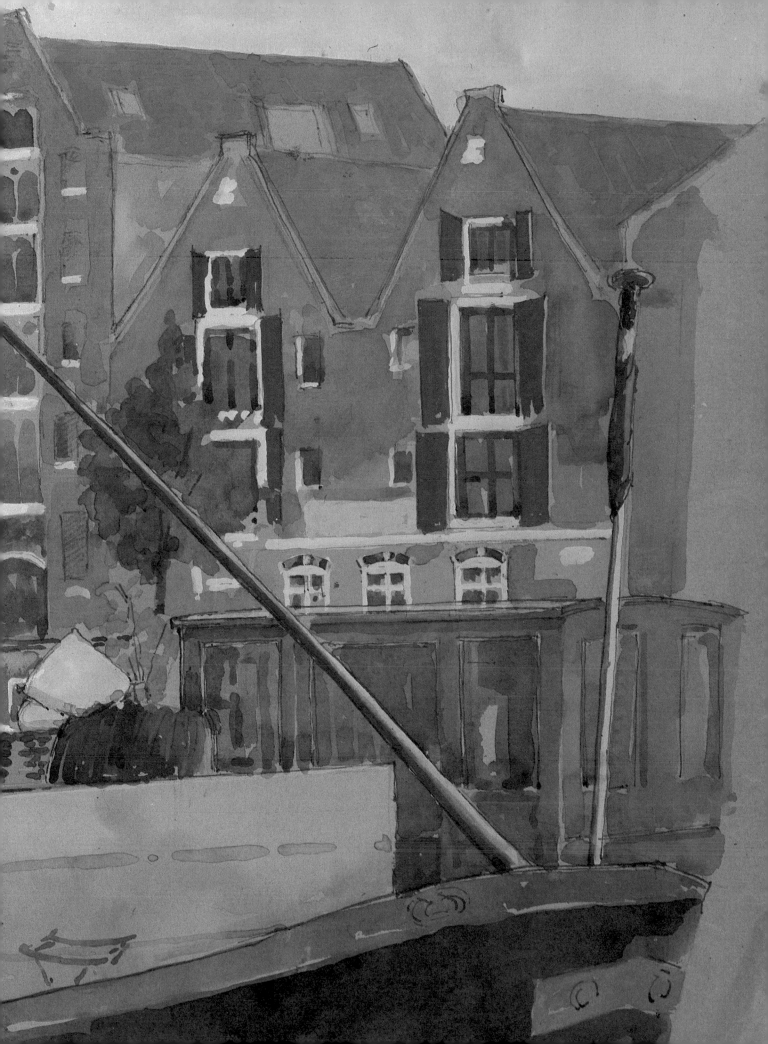

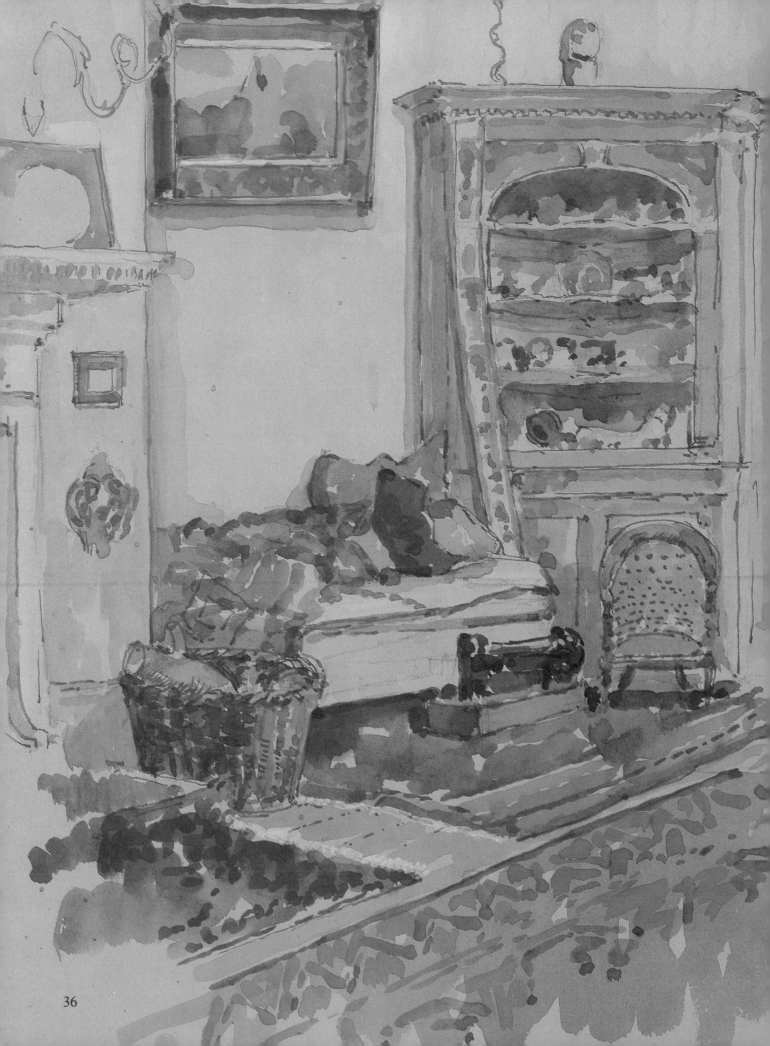

The visual excitement of dancers as a subject, at least for me, is endless. It is particularly interesting when there are two or more performers because then the relationship between them becomes so important.

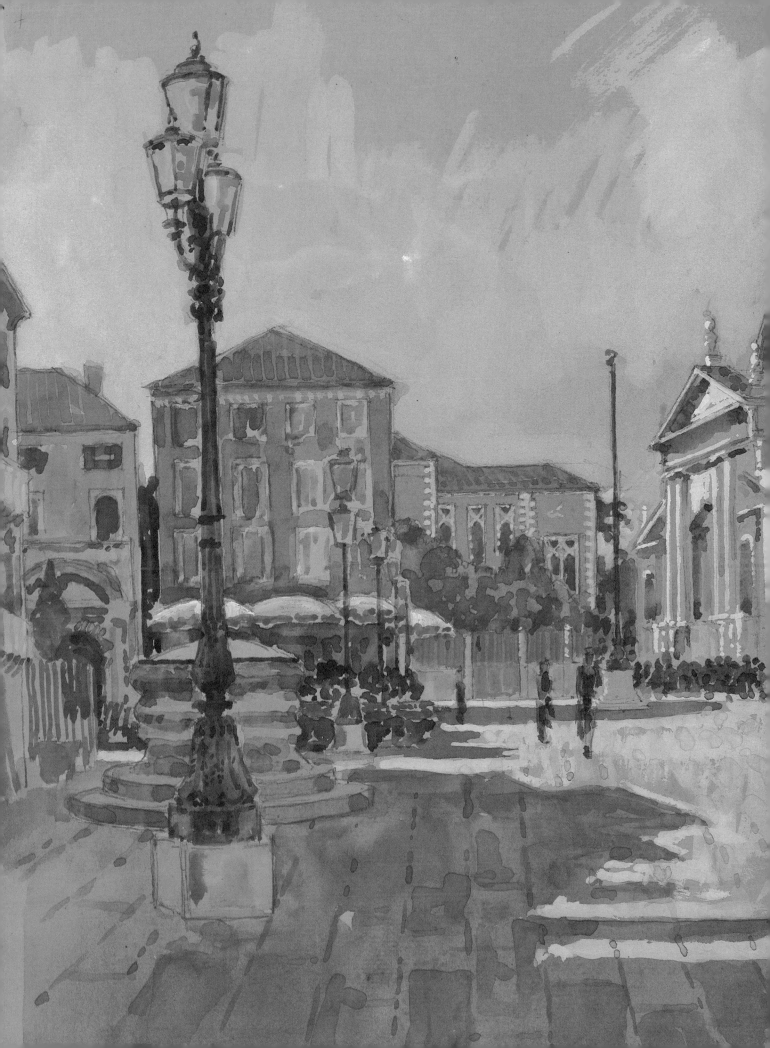

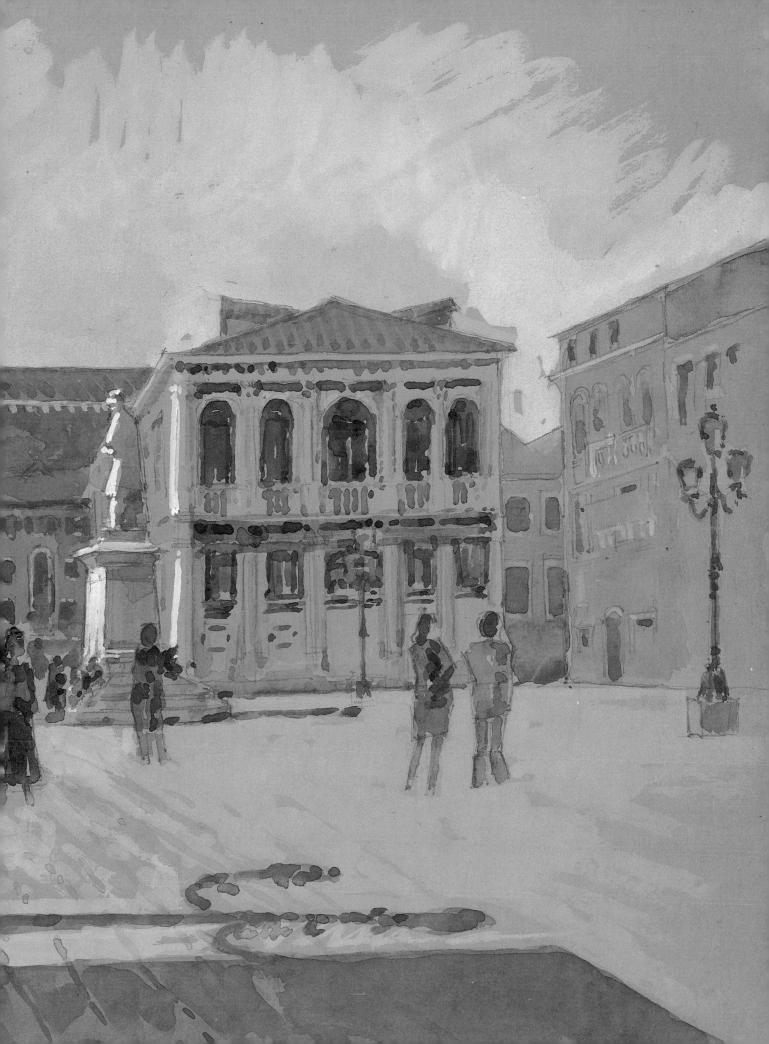

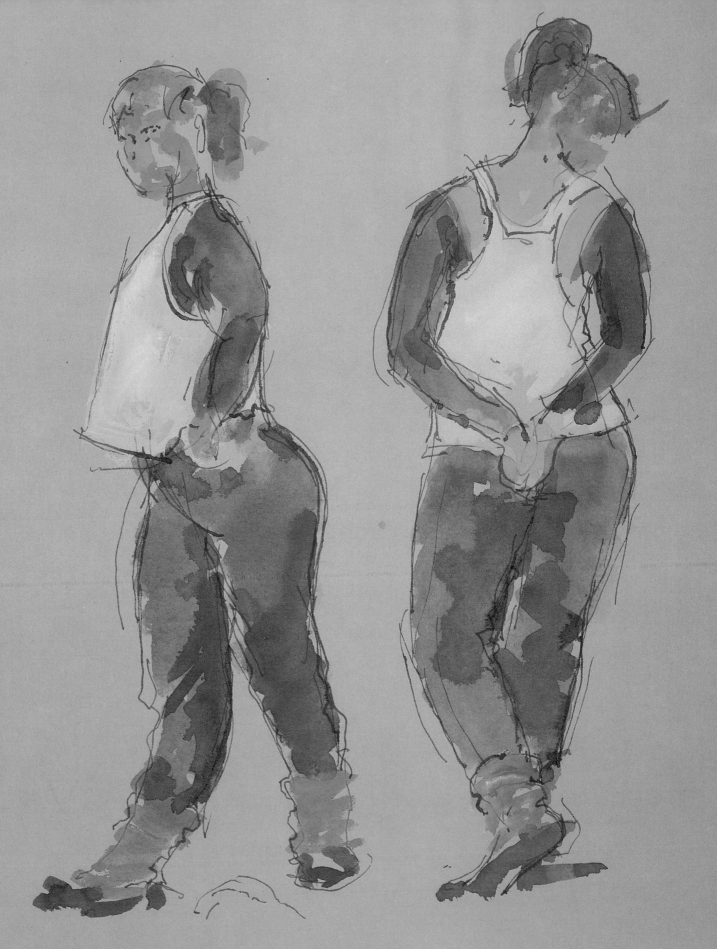

Dancers are just as interesting when they are simply exercising or even resting. I always find all aspects of a dance session worth recording.

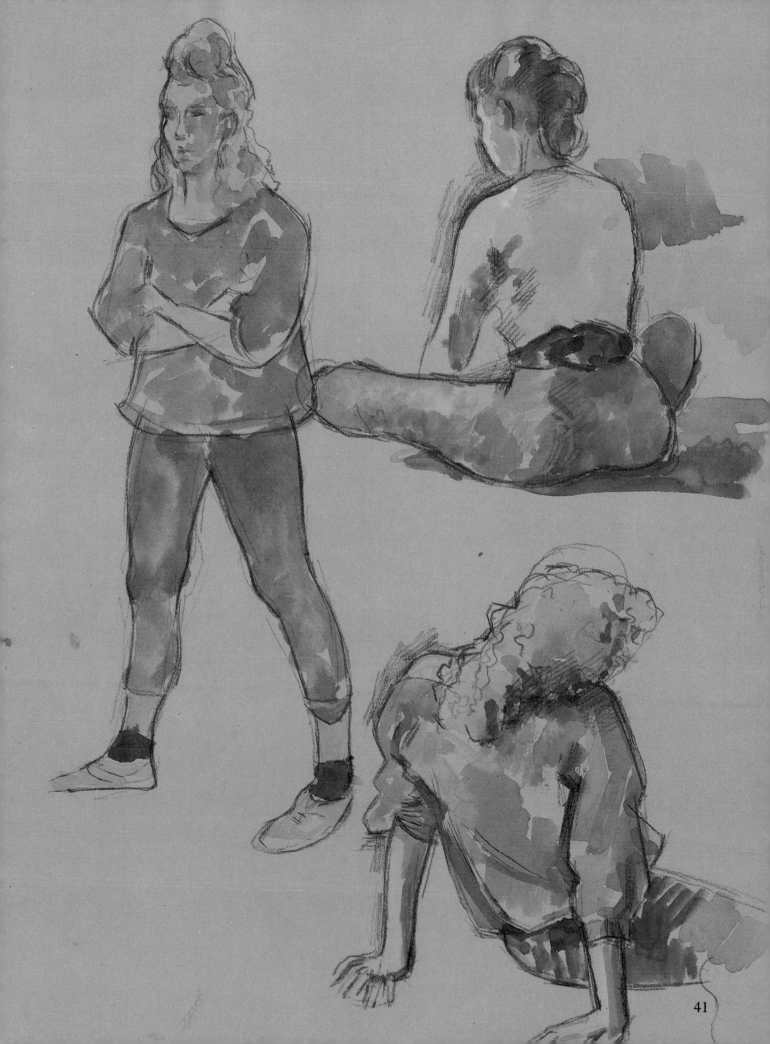

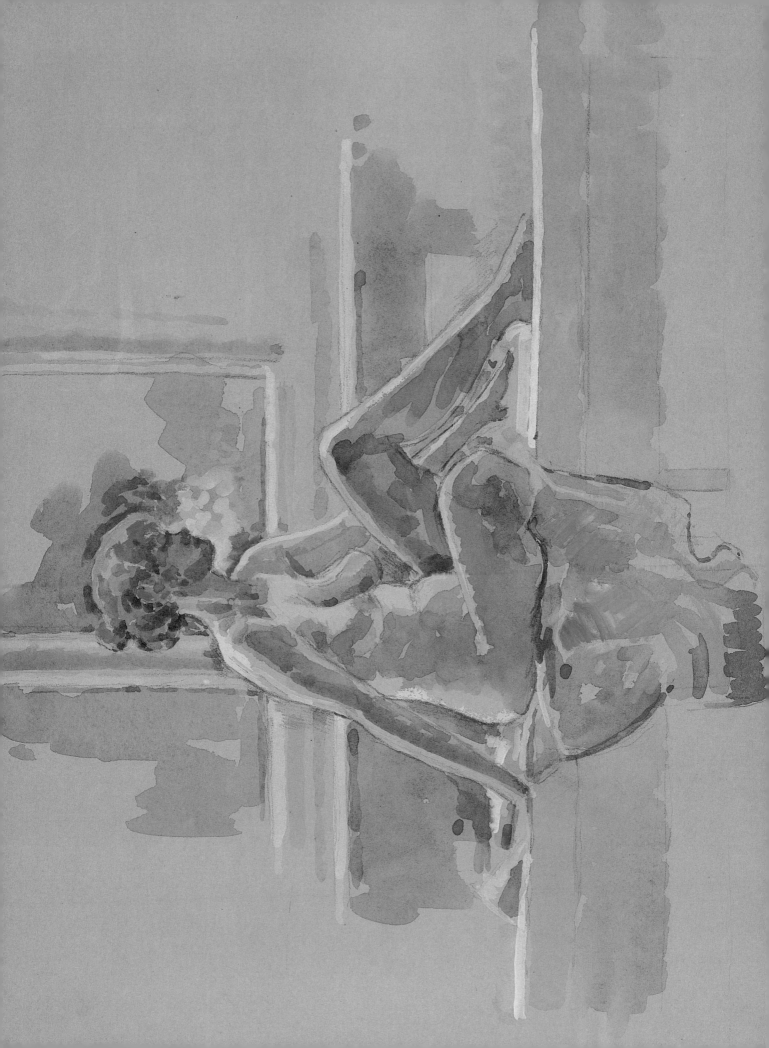

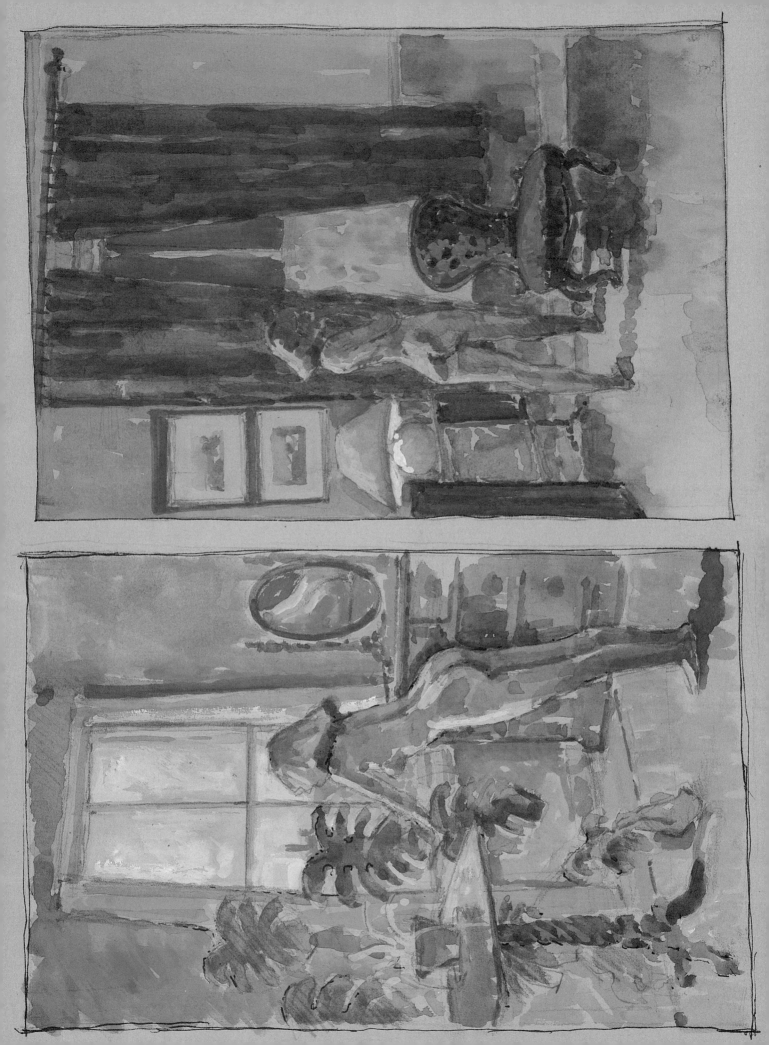

This was a first study for an idea that I eventually painted on quite a large scale. Drawings like this can often turn out to be quite satisfying in themselves even though the original intention is to explore a subject for further development.

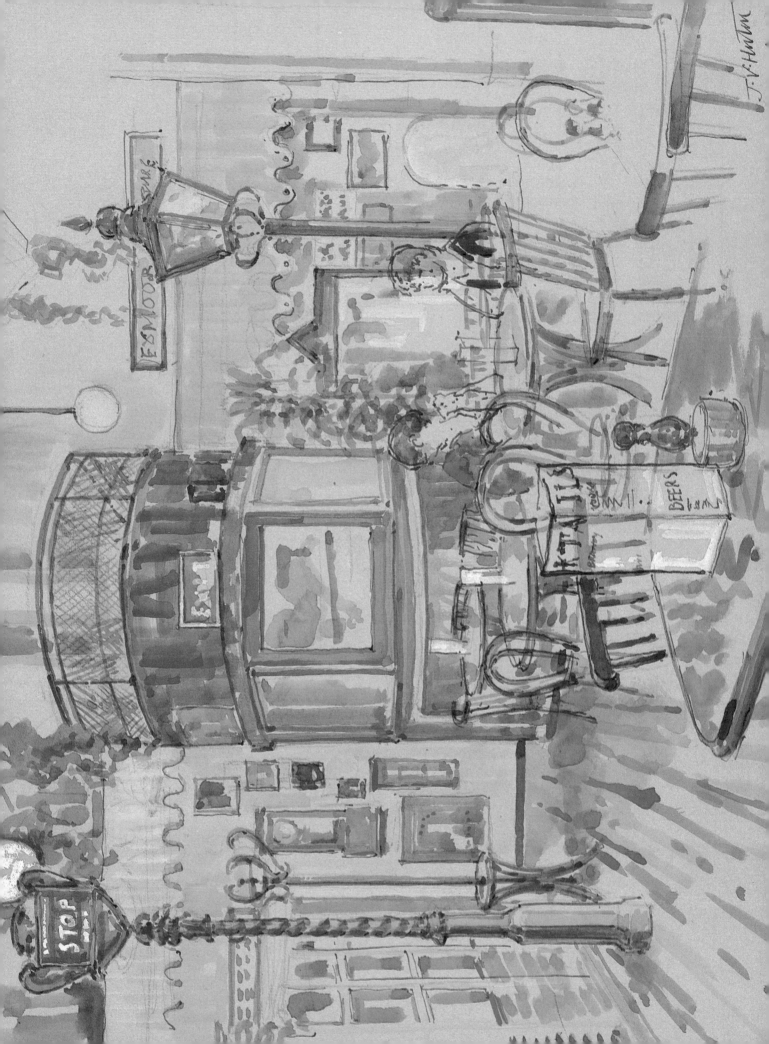

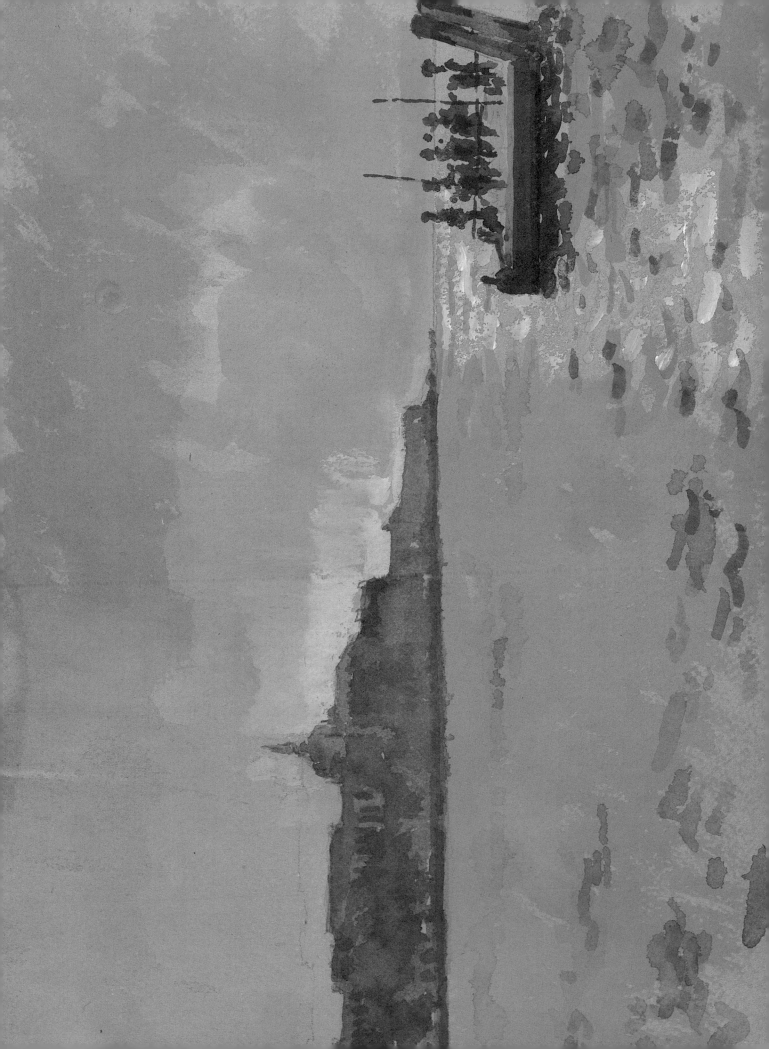

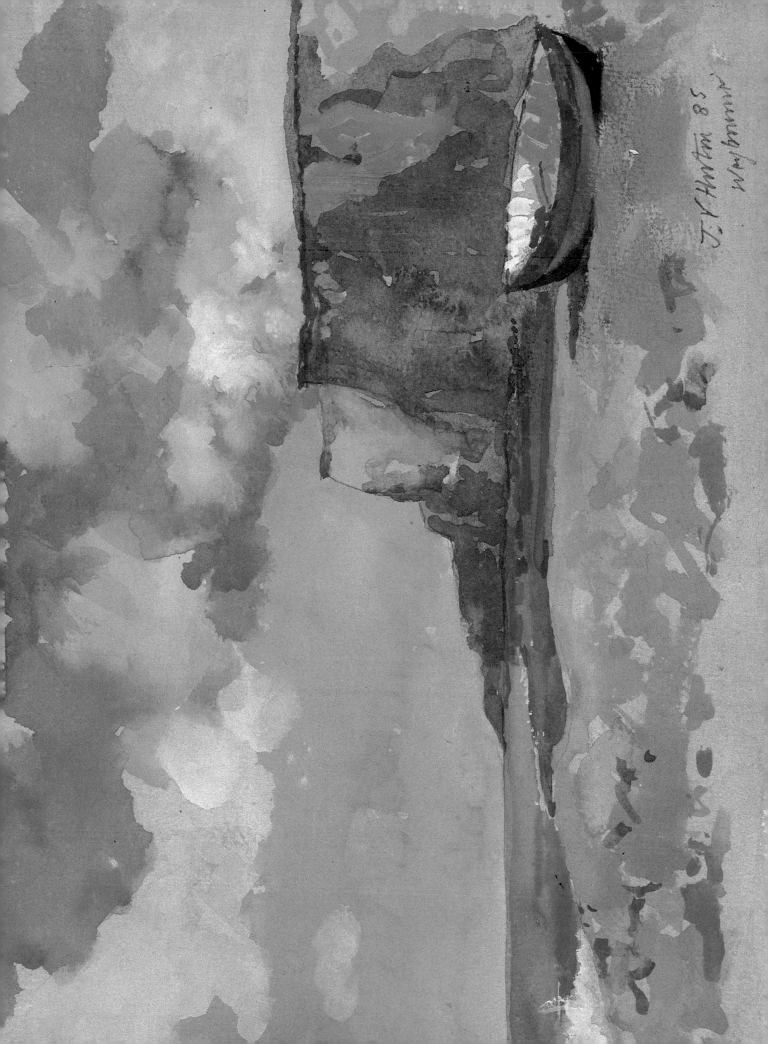

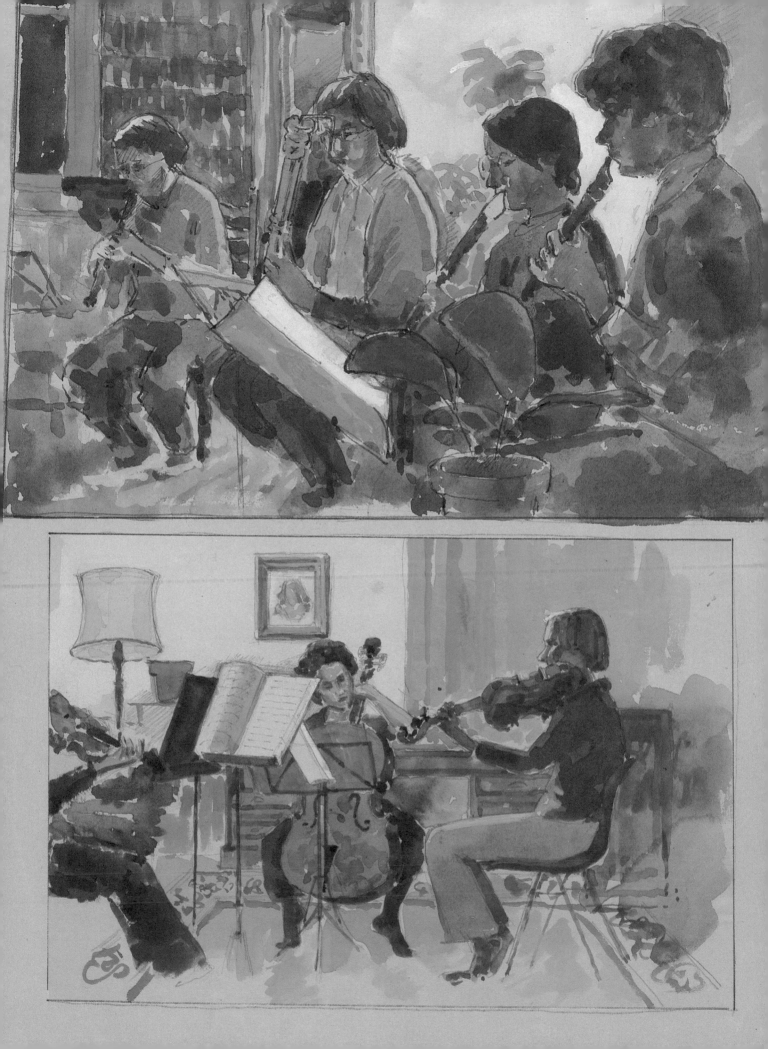

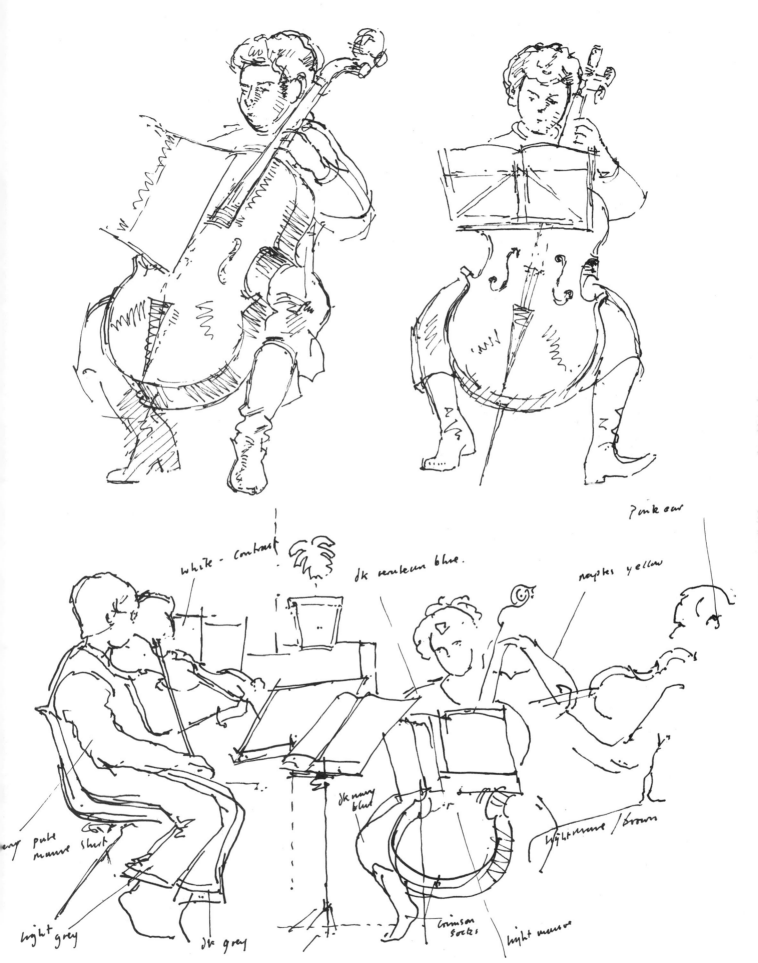

white - contrast

dk venterun blue.

Pink ear

naples yellow

my pale
mauve shirt

light grey

dk grey

dk navy
blue

crimson
socks

light mauve

lightmauve / brown

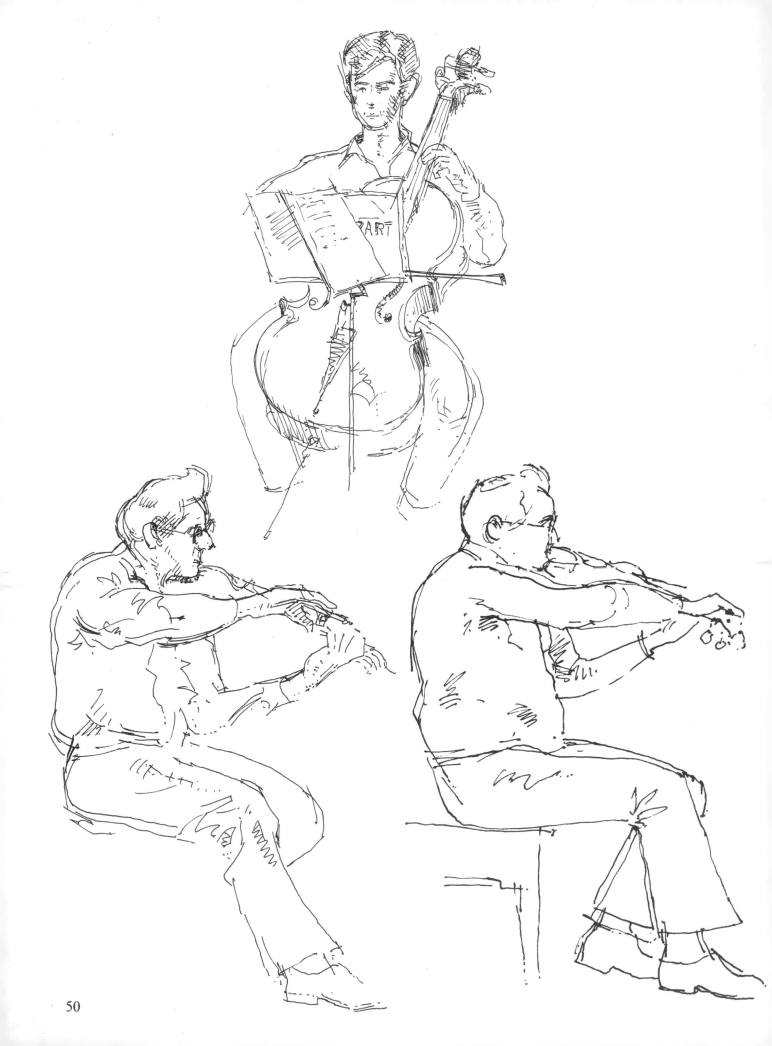

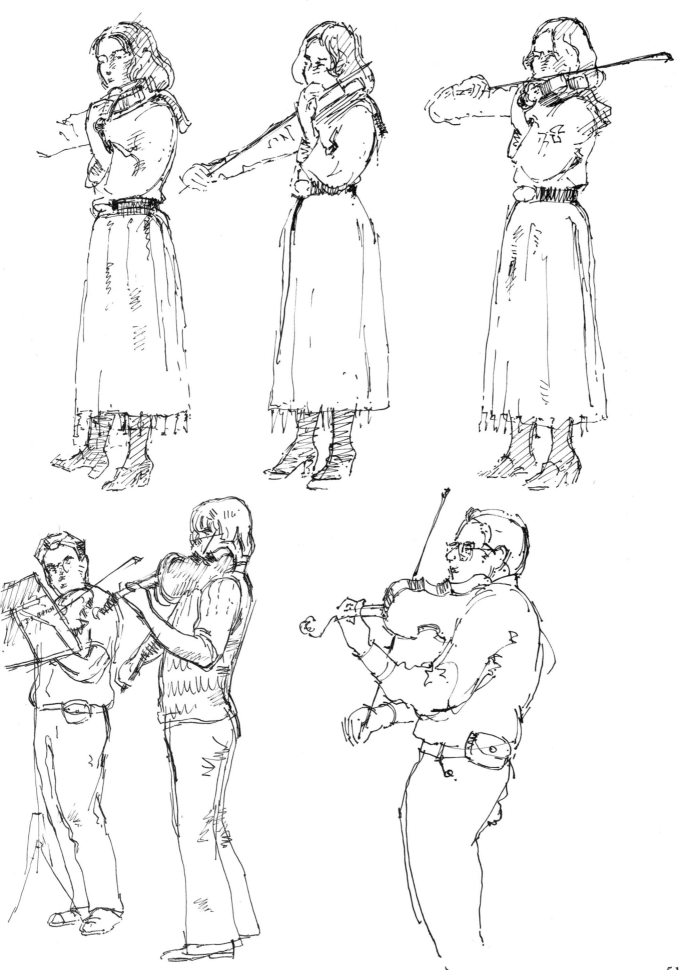

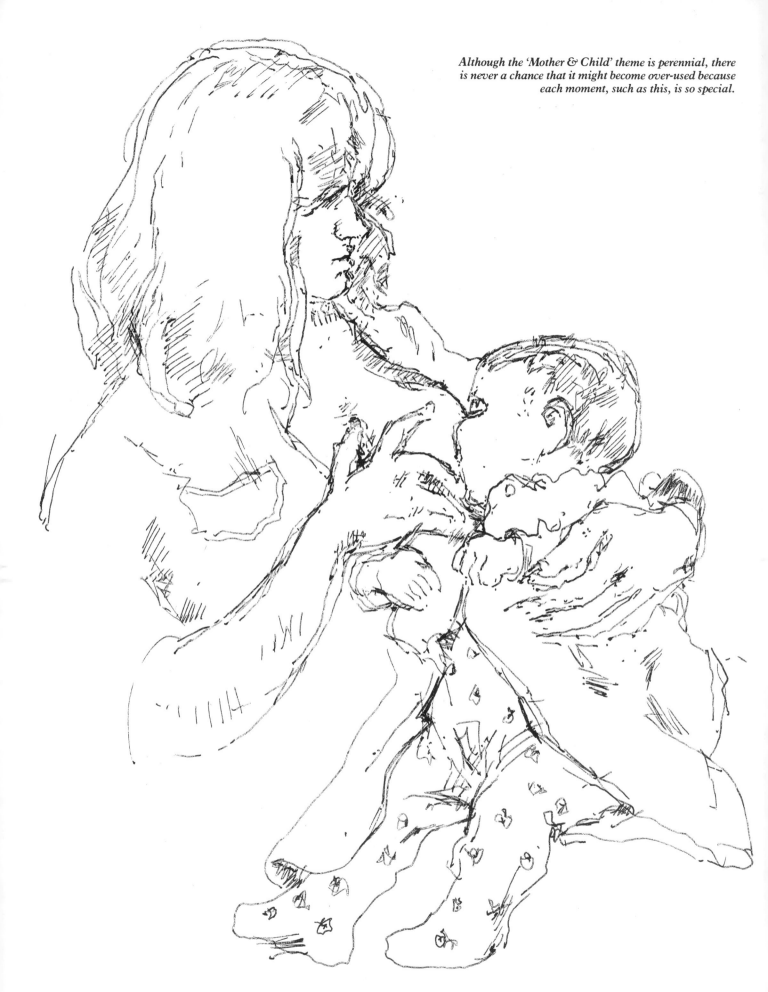

Although the 'Mother & Child' theme is perennial, there is never a chance that it might become over-used because each moment, such as this, is so special.

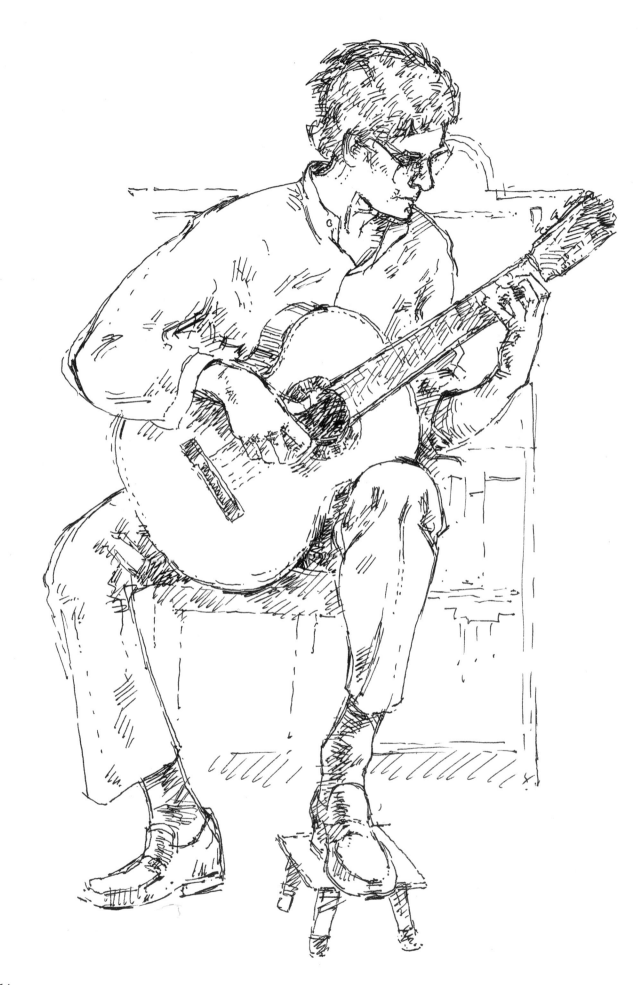

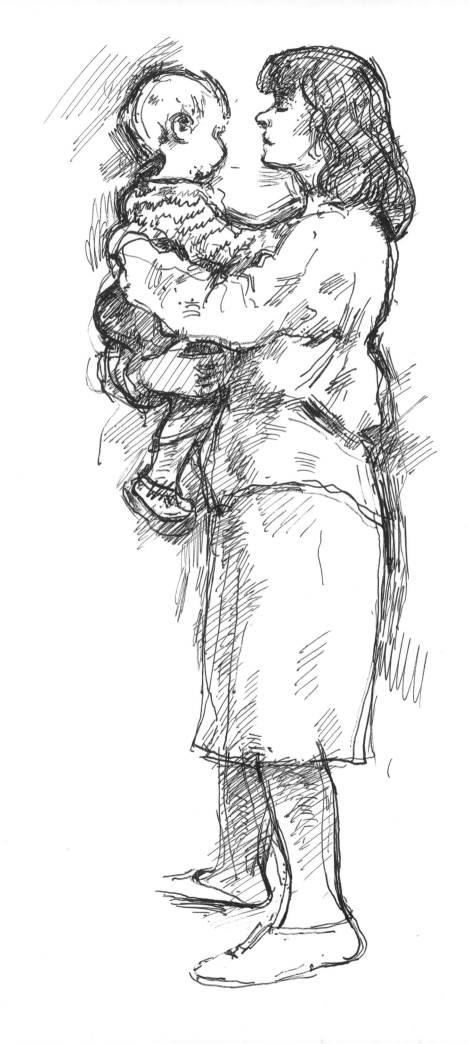

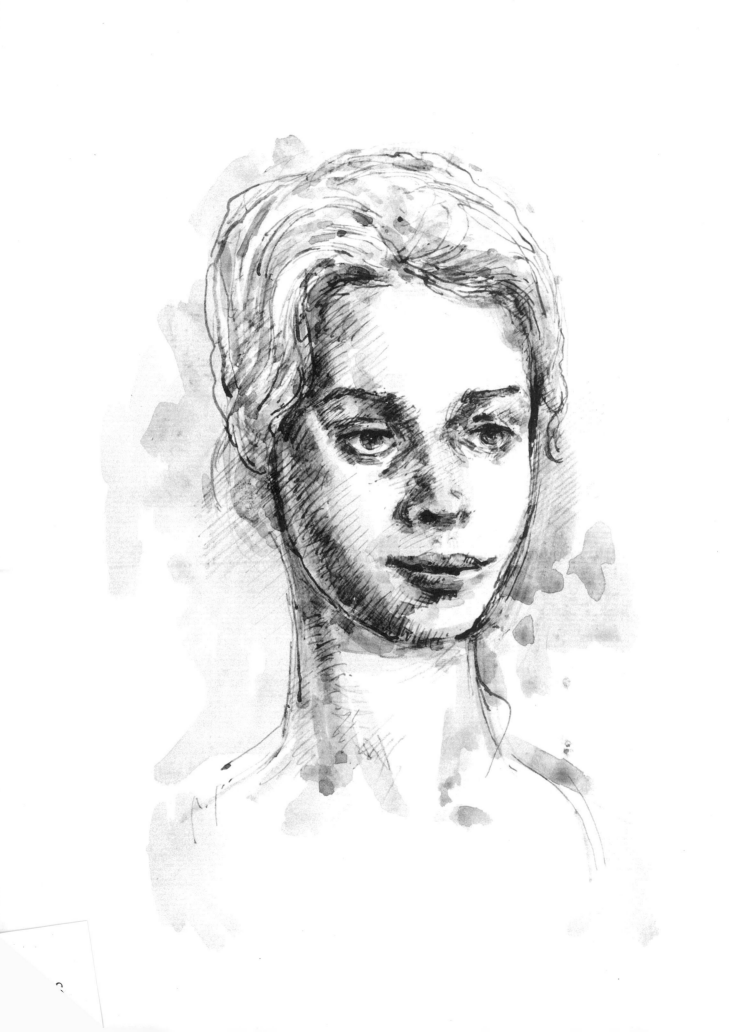

This was drawn on a coach after an extremely rough and alcoholic Channel crossing! The two girls were shattered on reaching land and went straight into a deep sleep. I just had to draw them.

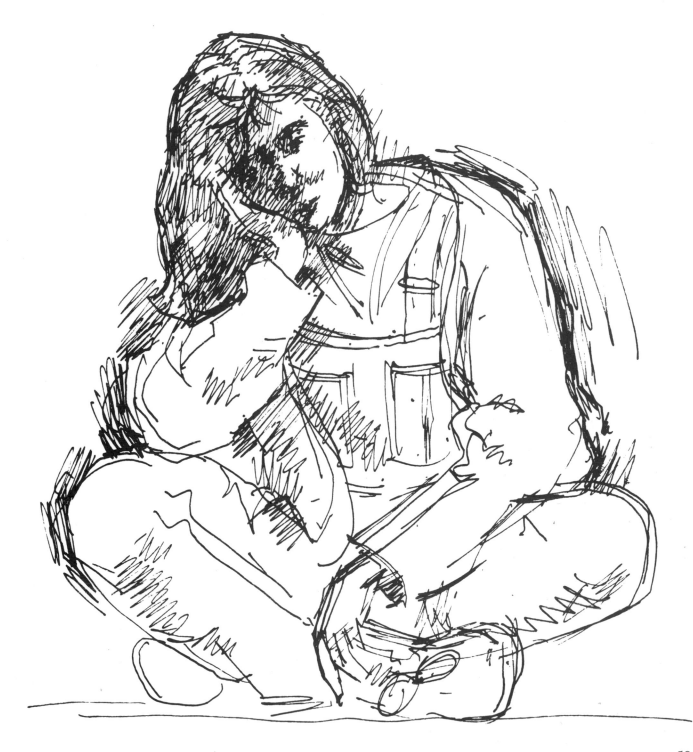

This girl shows her boredom at being made to pose for a life class at which the model had not turned up.

Drawing this bridge in Amsterdam was a severe test of patience and draughtsmanship. It was an enjoyable challenge during which I was continually reminded of the need for solid construction, not just in the subject but also in my drawing.

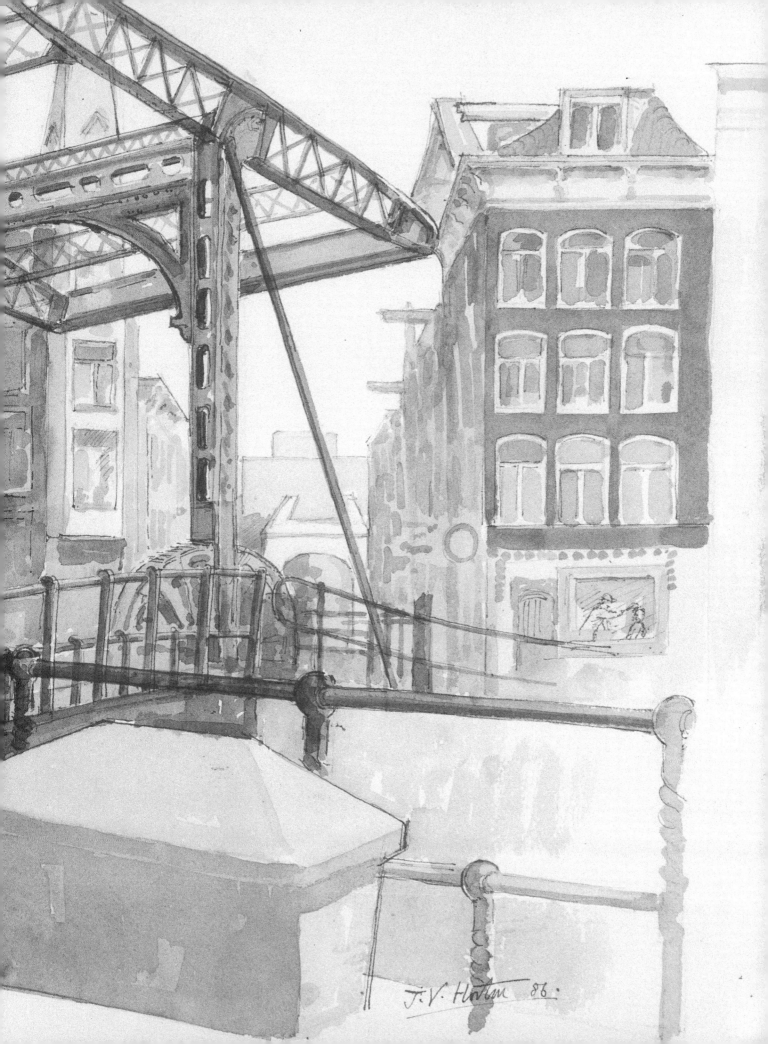

J.V. Hoven 86.

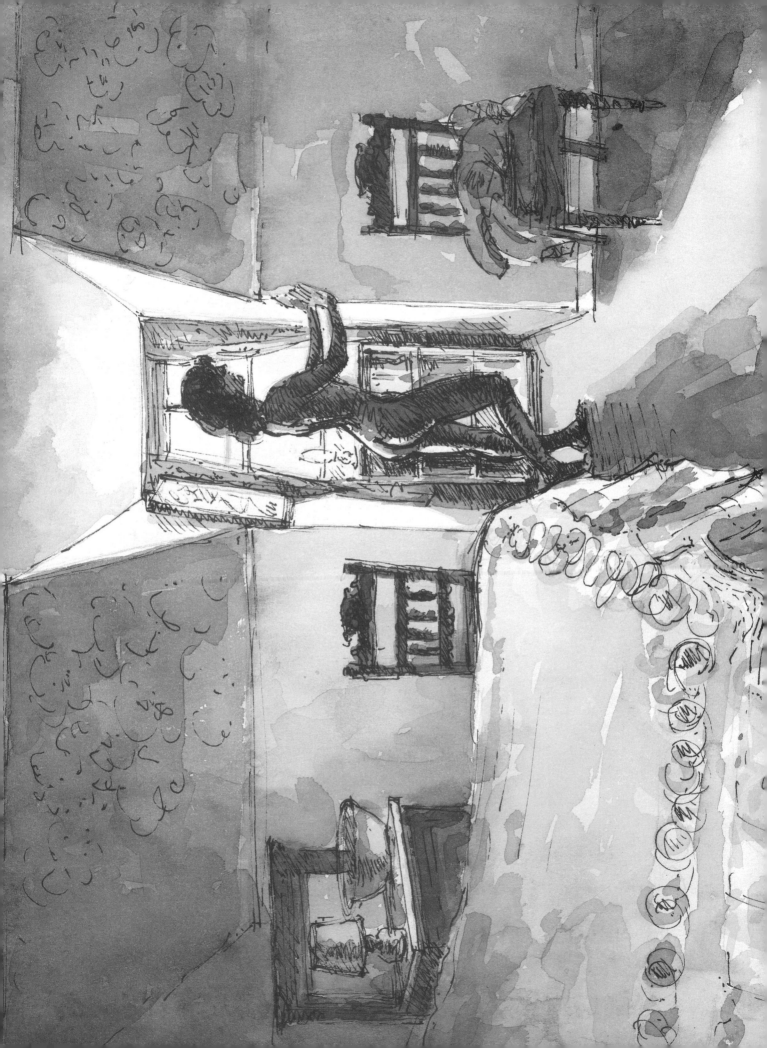

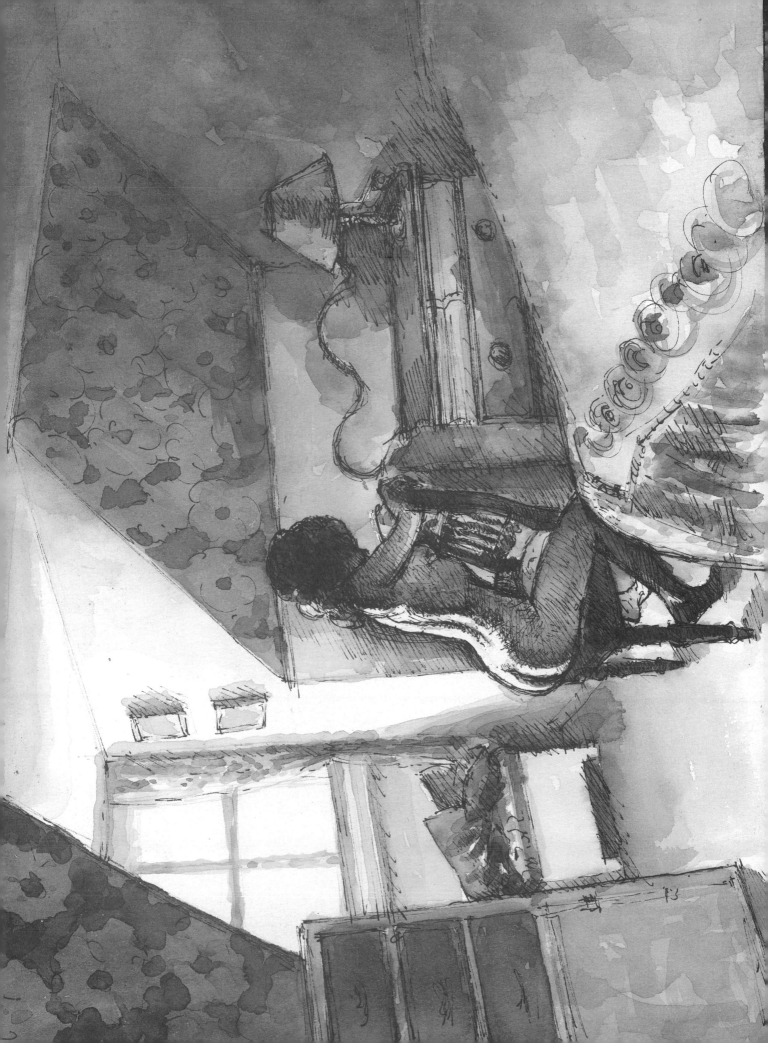

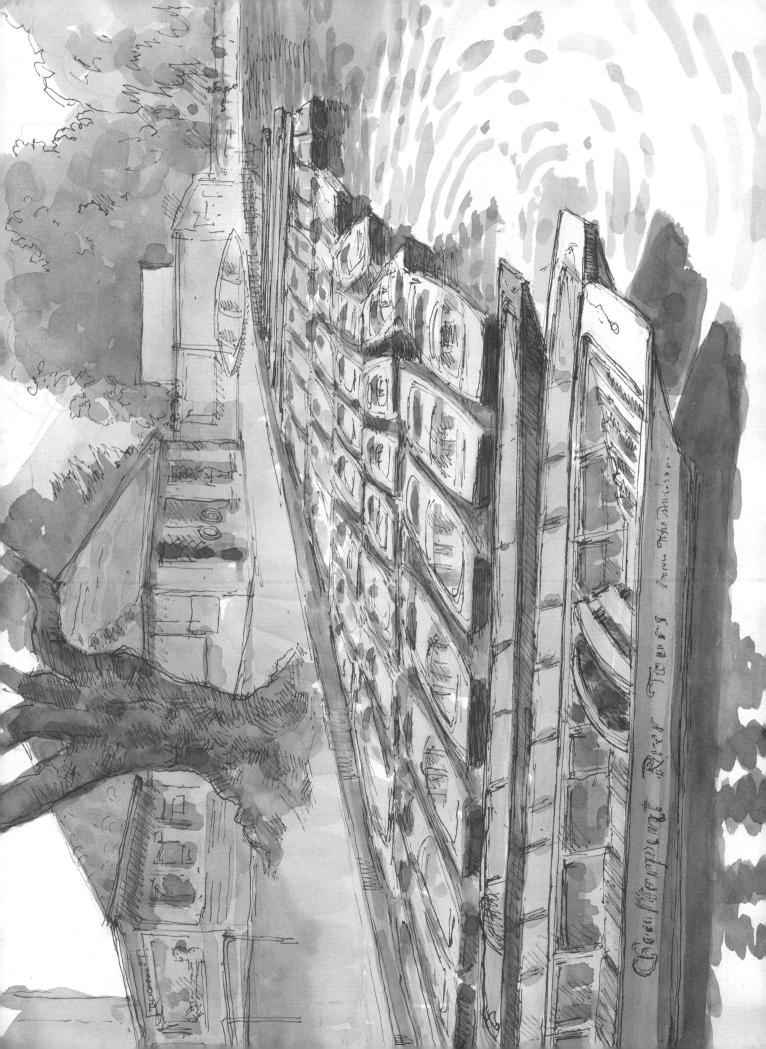